PENGUIN CLASSICS

The Beauty of Everyday Things

Soetsu Yanagi (1889–1961) was a philosopher, art historian, aesthete and poet. He evolved a theory of why certain objects made by unknown craftsmen were so beautiful, and became the founding father of the Japanese folk crafts (*mingei*) movement. He helped establish, and was the first director of, the Japan Folk Crafts Museum.

SOETSU YANAGI

The Beauty of
Everyday Things

Translated by Michael Brase

PENGUIN BOOKS

Note to the Reader: Japanese names are given in Japanese order
(surname first) for persons active before the Meiji Restoration of
1868, and in Western order (surname last) for persons active
thereafter. Macrons are not utilized.

PENGUIN CLASSICS

UK | USA | Canada | Ireland | Australia
India | New Zealand | South Africa

Penguin Books is part of the Penguin Random House group of companies
whose addresses can be found at global.penguinrandomhouse.com.

Penguin
Random House
UK

First published in Japan as *Soetsu Yanagi: Selected Essays on Japanese Folk Crafts*
by the Japan Publishing Industry Foundation for Culture (JPIC) 2017
This edition published in Penguin Classics 2018

017

The essays appearing in this book were selected from *Yanagi
Soetsu korekushon 2: mono* (Chikuma Shobo; chapters 2–7, 10–14)
and *Mingei yonju-nen* (Iwanami Shoten; chapters 1, 8, 9, 15, 16)

Translation copyright © Japan Publishing Industry Foundation for Culture, 2017
Photographs copyright © The Japan Folk Crafts Museum

The moral right of the translator has been asserted

Set in 12/16.5 pt Haarlemmer MT Pro
Typeset by Jouve (UK), Milton Keynes
Printed and bound in Great Britain by Clays Ltd, Elcograf S.p.A.

A CIP catalogue record for this book is available from the British Library

ISBN: 978-0-241-36635-6

www.greenpenguin.co.uk

CONTENTS

WHAT IS FOLK CRAFT?
1933

I. The Origin of the Word *Mingei*

The Japanese word for 'folk craft' or 'folk art', *mingei*, is actually new to the language. Being new, it is often confused with tribal art, peasant art, or even the more inclusive arts of the common people. In coining this word, however, Shoji Hamada, Kanjiro Kawai, and I had something simpler and more direct in mind. We took the word *min*, meaning 'the masses' or 'the people', and the word *gei*, meaning 'craft', and combined them to create *mingei*. Literally, the word means 'crafts of the people'. It is meant to stand in contrast to aristocratic fine arts, and refers to objects used by ordinary people in their daily lives. These objects include household effects such as clothing, furniture, eating utensils, and stationery. In common parlance they are referred to as 'ordinary things' (*getemono*),

3

'the roughly made' (*sobutsu*), and 'sundry implements' (*zatsugu*). All of these are counted as *mingei* or folk craft.

Folk craft objects in this sense have two principal features. One is that they are things made for daily use. Second is that they are common, ordinary things. Conversely, they are neither expensive nor produced in small numbers. Their creators are not famous artists but anonymous artisans. They are not made for viewing pleasure but for daily use. In other words, they are objects indispensable to the daily life of ordinary people, that are used in commonplace settings, that are produced in large numbers, and that are inexpensive. Thus, among the various types of handicrafts, broadly speaking, folk crafts are those crafts that are deeply embedded in the life of ordinary people.

However, when coining the word *mingei*, in addition to this broad meaning we also wanted to define the term more narrowly. If we simply defined *mingei* as referring to practical objects used by ordinary people, all kinds of cheap things commonly displayed in stores would fit that criterion. Among *mingei* objects we wanted to include

only those with certain specific characteristics. One essential feature should be that the objects honestly fulfil the practical purpose for which they were made. In contrast, look at the machine-made objects that inundate our lives in recent years, which have fallen victim to commercialism and the profit motive, usefulness shunted aside. Among these objects ostensibly made for practical use, there are many that are nothing more than frauds and fakes, displaying no attempt at honest usability. On the other hand, there are the many purportedly refined objects that aim at elegance but succumb to bad taste, overburdened with needless decoration and meaningless frivolity. With these works utility becomes a secondary consideration, verging on the enfeebled and morally corrupt. In objects of daily use these are precisely the characteristics that should be avoided, for they have turned their backs on the life they should be serving.

Thus in order to be called *mingei* an object must be wholesomely and honestly made for practical use. This calls for the careful selection of material, the employment of methods that are in keeping with the work to be done, and

attention to detail. It is only this that produces bona fide objects that will be of practical use in life. Looking at recent works, however, what one sees is an emphasis on visual appreciation over utility and the cutting of corners in the production process, resulting in objects that can only be called feeble and ugly. The fact that the colouring is vulgar, the shapes thin, weak, and prone to break, and that the finish easily flakes, all this comes from a lack of honest attention to the objects' utilitarian purpose. I am tempted to call this type of work amoral and unethical.

Folk craft is thus devoted to healthy utilitarian purposes. It is, in fact, our most trustworthy and reliable companion throughout our daily lives. Essentially, it is easy to use and ready at hand, always reliable once we have become familiar with it, provides a sense of ease and comfort, and the more we use it, the more intimately it becomes a part of our lives. Folk art may be rough in nature, but it should not be slipshod. It may be cheap, but it should also be sturdy. What must be avoided at all costs is dishonest, distorted, and ornate work. What must be sought is the natural, direct, simple, sturdy, and safe. In a word, folk art

must be sincere, sincerely produced for use by the common person. It is the aesthetic result of wholeheartedly fulfilling utilitarian needs. Its beauty can be called wholesome or natural.

II. The Need for Folk Craft

The majority of crafted objects are made for common use in our everyday lives. If we want this overwhelmingly predominant ordinary craft-ware, vis-à-vis fine-art craft, to flourish in the years ahead, we must ensure that, as a whole, it evolves in quality. An analogous situation can be seen in society at large: if society contains a few outstanding individuals but the mass of people is mediocre, society as a whole will not prosper. In the world of handicrafts, until just recently it was thought that anything would suffice for common ware, since it was merely for day-to-day use, nothing more. If this were true – that anything will do no matter how badly made – we could never achieve the idyllic Kingdom of Beauty where all crafted objects are beautiful. If only a few select fine-art objects are beautiful, this ideal world will never be realized.

7

Similarly, if only a few priests are faithful to their religious beliefs, the world of religion can no longer be said to exist. For the kingdom of God to appear on earth, it is necessary for faith to be widely spread among the people. Likewise, it is my belief that for an idyllic age of craftware to appear among us, it is essential that ordinary crafted objects be saved from demise. Folk objects are the acme of all crafted ware. Their decline means the decline of all handicrafts. Without a healthy folk art tradition, craftware in general will lose its way. Needless to say, regardless of the country, eras in which ordinary objects were things of beauty were eras in which craftware as a whole blossomed. Among the finest works of the past, it is pellucidly clear that the most splendid of all were the folk handicrafts.

In recent times a shadow has fallen on our sense of beauty, on our aesthetic sensibility. There are undoubtedly many reasons for this, but one is certainly the fact that our everyday utilitarian utensils and implements have become so ugly. It is these ugly things that surround us throughout the day, from morning to night – the

clothing we wear, the utensils we eat from, the furniture we make use of. Without our realizing it, these unattractive objects have had an enormous impact on our sensitivity to beauty.

We no longer look upon objects as we used to, which is undoubtedly due to their poor quality. In the past, everyday objects were treated with care, with something verging on respect. While this attitude may in part have been a result of the scarcity of goods in past times, I believe it principally resulted from the honest quality of their workmanship and the fact that the more an object was used, the more its beauty became apparent. As our constant companions in life, such objects gave birth to a feeling of intimacy and even affection. The relation between people and things then was much deeper than it is today. When a person could point to what he was wearing and say, 'This belonged to my grandfather', it was a source of pride. These days, however, the careless way things are made has robbed us of any feeling of respect or affection. From the viewpoint of social mores, this is a huge loss.

These days personal taste has suffered a decline, colours have become garish, forms flimsy,

and designs hideous. It is only natural that, surrounded by such objects, our sense of beauty should be dulled. An elite group of artists may produce objects that are aesthetically pleasing, but that in itself doesn't make the world around us any more beautiful. On the contrary, the influence of the ugly and deformed continues to grow ever stronger. If it is our ideal to live in a world surrounded by beautiful things, in a virtual Kingdom of Beauty, then we must raise the ordinary things of our daily lives to a higher level. The way to do this is not to place emphasis on appearance to the detriment of utility. Religious leaders attempt to reach the hearts of the masses in order to save the world. Why then don't those who strive to become artisans seek to save the folk arts? Unless they are saved, the world will turn out to be a very dull place.

Here I would like to say a little more about why I emphasize the utilitarian aspect of craft objects. Until now we have been taught that the right way to appreciate beauty is through visual perception. This has applied principally to the so-called fine arts such as painting and sculpture. Even with handicrafts we have been taught

to value craftware with little connection to its use, that is, craftware made for visual appreciation. Utilitarian crafts have been looked down on as something of a lower rank. As a result, our aesthetic sense has been severely impaired owing to the fact that beauty and life are treated as separate realms of being. Beauty is no longer viewed as an indispensable part of our daily lives. Confining beauty to visual appreciation and excluding the beauty of practical objects has proven to be a grave error on the part of modern man. A true appreciation of beauty cannot be fostered by ignoring practical handicrafts. After all, there is no greater opportunity for appreciating beauty than through its use in our daily lives, no greater opportunity for coming into direct contact with the beautiful. It was the tea masters who first recognized this fact. Their profound aesthetic insight came as a result of their experience with utilitarian objects. By going beyond the visual to practical use, the tea masters made deep inroads into the search for beauty. Their world was one of craft, not art. They gained their profound knowledge of beauty by seeking it in the utilitarian objects deeply rooted in daily life.

It is true that, with the passage of time, this beauty was confined to the teahouse. But the tea masters' true aim, I believe, was to experience the world of tea in the everyday use of ordinary objects in our personal lives.

It is my personal belief that without a healthy folk art tradition, the world cannot become a place replete with beauty. If life and beauty are treated as belonging to different realms, our aesthetic sensibilities will gradually wither and decline. I earnestly believe that in order for beauty to prosper in this world, and in order for us to gain a deeper appreciation of beauty, it is necessary for the utilitarian to also be the beautiful. If folk crafts grow weak and feeble, this world of ours will never be a Kingdom of Beauty. And if folk art withers and declines, the handicrafts in general will eventually wither away. This stands to reason, for folk art is the craft that is most intimately connected with daily life.

III. The Realization of a New Folk Craft

Given the above, how can we revive, mature, and bring the folk arts to fruition once again?

What approach, what path, should we take to accomplish this end?

It is common knowledge that the mechanization and commercialization of industry have resulted in the unending manufacture of poorly made goods. This decline in quality is the result of the excesses of the profit motive, organizational distortions, technical limitations, and much more. Furthermore, the working conditions in factories are oppressive, and workers find their work to be meaningless. Add to this the fact that there are no restrictions on mechanization, which leads to rampant production of an even lower quality. Overproduction has also produced a greater number of unemployed. No one takes responsibility for this lamentable situation: not those who order the goods, not those who make them, nor, obviously, the products themselves. These abnormal phenomena eventually affect the objects made. Moreover, the influence of the large cities is so strong that it has led to a deterioration of provincial life, where production has become uniformly the same and monotonously repetitious. It is clear that the chilling confines of the factory are not conducive to the

fostering of folk art in its true sense. Modern-day organization, machinery, and labour conditions are not suited to the honest and sincere production of utilitarian ware. Unfortunately, the present trend appears to belittle honest, sincere workmanship as silly and frivolous.

Turning to the provinces, we find that although the artisans there are without work, the handicraft tradition is still alive. Special techniques are still being passed on. The people there are still honest and reliable. Given this, it is absurd to leave the production of craftware in the hands of urban factories. It seems to me that the most natural and surest way of getting the *mingei* movement under way is to start from provincial handicrafts. As a side job, provincial handicrafts could also play an economic role, particularly in the now-impoverished farming villages where jobs are few and work warmly welcomed. Some people want to abandon handicrafts as a thing of the past, but for me what matters is not whether the manufacturing is new or old but whether the work is honest and sincere. To my mind, in order to get handicrafts back on the right path it is best to think of them

as a provincial industry, for the provinces are the farthest removed from the various evils that eat into the heart of folk craft. Particularly in the case of a country like Japan, where folk art is still alive in the provinces, this seems the most effective way to make use of that latent strength.

In brief, what is needed to revitalize folk craft is the strengthening of provincial distinctions, the support of family kilns, the effective use of handicraft traditions, and a solid foundation based on local materials. These are the factors that will produce good workmanship, for they are positioned on a secure, natural basis.

The objects themselves, however, should not be a simple repetition of what has been done in the past. Recent lifestyles have changed and require new objects for everyday use. As long as the aim of folk art is the creation of utilitarian objects, it must meet the needs of the new age. While most people think of toys and dolls when provincial crafts are mentioned, these objects tend to be mere playthings. For the healthy growth of folk art, it is far better to focus on utilitarian objects, to refrain from establishing craftwork on a foundation of hobbies and pastimes unrelated to

the practical aspects of everyday living. Since folk art provides utilitarian ware for large numbers of people, it has to be developed as an industry. Making it an individual enterprise will go against the very essence of folk craft. The aim of folk crafts should be neither individualistic artistic expression nor the satisfaction gained from owning something produced in small numbers and therefore rare. Crafts that aim at making a contribution to life should eschew individual ambition. It is far better to strive for the plain and natural. This is more in keeping with the ideal of beauty.

Folk craft is the province of craftsmen. It is not a world inhabited by single individuals, but a world of cooperative effort. This is the world where craftwork is properly carried out, a world where quality is guaranteed by group effort. Cooperation produces far greater results than the individual could ever hope to achieve. It also conforms to humankind's hopes for a more harmonious, cooperative future. The finest folk objects of the past are monuments to cooperative effort.

There is not a great difference in the capabilities of past and present craftspeople. It is

true, however, that since the general appreciation for beauty has declined, the notion of what is good and bad is gradually being lost. This cannot be blamed on the craftsmen themselves. It is the times we live in that are at fault. If artisans were only given a direction, if only some force brought them together, their work would come to life again. To simply leave everything in their hands and observe the results would be a risk not worth taking. The folk art movement needs a leader, someone who can specify the criteria for a good folk object. Without this, artisans will simply be wandering in the dark.

Next I would like to discuss the connection between individual craft artists and folk art craftsmen. It seems proper that the work of knowledgeable and creative individual artists should serve as an inspirational model for folk craft workers. Until now, the work of such artists has stopped at the individual level. They have prided themselves on work that no one could possibly emulate. In the future, I expect, their objective will be to infuse their originality into the work of others. As primary movers they will seed their work in the field of folk art and

see those arts flourish. It is perfectly acceptable for individual artists to be the leaders and folk craftsmen the followers. Through the collaboration of these two forces, the world of craft will quickly achieve unprecedented results. It goes without saying that the individual artists must be cognizant of folk art's significance.

It seems clear from this that there is need for an organization to carry on the folk art movement and see it to fruition. Insofar as it is not a matter of the individual working alone, and insofar as it is a collaborative effort by many craftsmen, there is need for some kind of order, some kind of systematic, legitimate organization. Such an organization could overlook the artisans' activities and protect their collective interests. It is only by coming together as a group that individually weak artisans can become a force to be reckoned with. However, this organization should not be ruled by a hierarchical authority as heretofore. Neither should it be ruled by mere profit and loss. The fact that the present distribution system has been the ruin of handicrafts must also be kept firmly in mind. It is only by banding together in mutual respect that individual

craftspeople can safeguard and preserve the folk crafts. Only an organization superseding individual artists can effectively shield the folk arts from depredation.

IV. The Aims of Folk Craft

There are two reasons that I and like-minded friends first became interested in folk art. The first is the fact that we were struck by the beauty of folk crafts. The second is that we came to fathom the reasons for that beauty. Based on intuitive insight and rational consideration, we became convinced that the promotion of folk art was eminently important for handicrafts in general. However, given the debilitated condition of contemporary folk art, such promotion would necessarily have to be carefully planned and executed. What was the nature of folk art in the past, how was it made, what were its characteristics, how did it attain such beauty? All these things would have to be carefully studied and noted. This enormous undertaking would be a search for objective truth, an expansion of our thought processes, the attaining of a new awareness. The

folk craft movement would have to begin with this consciousness-raising search for truth.

While the commencement of the folk craft movement would have to encompass this type of awareness, it must not end with folk objects that are consciously created. Self-consciousness and self-awareness are essential to critics and creative artists but not to folk craftsmen. For folk craftspeople, the natural approach is that of unself-consciousness, unself-awareness. Our job as self-aware critics is to support them. We are not trying to make folk craftsmen into self-aware artists; that would make their work impossible. That would be equivalent to attempting to transform all people into 'good' people. Some Buddhist sects believe that all people will achieve salvation in the Pure Land regardless of merit, which is 'good news' for the great mass of people wishing to be redeemed. In the same way, all folk artisans, regardless of their lack of academic knowledge concerning their craft, are still capable of producing works of merit. They work as if this were the natural thing to do; they create as if this were the natural thing to do; they give birth to beauty as if this were the natural thing to do. They have

entered the way of salvation through unconscious faith. It is a path open to all. And once they have entered this path, the creation of plain, natural beauty becomes a thing of ease, a matter of course. This natural, unforced beauty is the result of a kind of unconscious grace. This grace is a special privilege of craftsmen and leads them to a realm of blessed unawareness. Without consciously thinking whether something is good or bad, creating as if it were the most natural thing in the world to do, making things that are plain and simple but marvellous, this is the state of mind in which artisans do their finest work.

I think I can clarify this state of mind through an analogy. For human beings, walking is the most ordinary of activities. Even the most simple-minded person can walk well. But no one is ever praised for being a good walker, and no one takes special pride in doing so. This is how I would like to view the artisan's state of mind when he is at work. No matter how good or bad an artisan's workmanship might be, the product is true folk art when it is made in this unconscious, natural manner. Many of the magnificent works of the past were made in this free and

unrestrained manner, as easy and thoughtless as walking. Such works were possible only because they were raised to the level of the ordinary.

Let us say that we have injured our legs, or that we have to walk at night without a light to show the way. Walking suddenly becomes less than an ordinary, unconscious activity. Care must be exercised with each step we take as we confront unwonted difficulties and unusual restraints on our movement. We realize how fortunate we were up to now to be able to engage in such an ordinary activity. This is the situation we now face with the folk arts. The folk arts have been injured, so we must be careful of each step we take. It turns out that placing one foot in front of the other is not such a simple thing; it has to be done with full awareness. But this awareness introduces a great many other difficulties to the actual working process. As with all new undertakings, what is required is extraordinary effort, painstaking care, and the will not to give up.

Clearly, this situation does not represent the intrinsic nature of folk art; neither does it represent a condition toward which folk art should

strive. Folk art should not be the result of an extraordinary sense of awareness; it must be something ordinary, born from the ordinary. There are cases where the plain and ordinary is far more significant than the extraordinary. For folk art to regain its health, shouldn't it return to that easy way of unself-conscious walking? That, after all, is the most ordinary of the ordinary. The more ordinary a thing is, the easier it is to do. Folk art is a product of such natural ease. If folk art is to develop into a wholesome, healthy art, it must be an art of the ordinary. Only then will it become something out of the ordinary.

Folk artisans are not individual artists working on their own. It is precisely because of this that they can meet the needs of folk art production, that they are able to accomplish feats impossible to the individual artist. The fact that they are able to create wholesome craft objects almost unconsciously is perhaps their most outstanding feature, a capability that, most fortunately, almost anyone can attain. The fact that, no matter how splendid their work, they look upon it as nothing special, as all in a day's work – this fact indicates how superlative these craftspeople truly are. Unfortunately,

people nowadays are ignorant of these subtleties. However, just consider that almost all of the great handicrafts of the past are folk objects. Consider that the creators of these works were groups of common workaday craftspeople. Consider that what we think of as extraordinary works of art were for them simply part of their daily routine; that for them such works were not a source of inordinate pride. They didn't incise their names on these superlative works – folk art is anonymous. It is the same with a person who does good works but takes no particular credit for them. It is the same with a Japanese who knows little grammar but can speak convoluted Japanese with ease. What a difference with foreign languages, where one has to be constantly conscious of grammatical structure! When one has achieved fluency in a language, it becomes second nature, a part of one's ordinary life, free to use as one pleases. In that sense, folk art should be something that anyone can easily do. The path of the self-conscious artistic genius is not the path of folk craftware.

While it is undoubtedly difficult for someone without an education to become a high priest, any person can become an ardent believer, for in

religion it is generally agreed that faith is more important than learning. Likewise, folk art is not a result of conscious study, and must not end that way. In the realm of beauty, is it proper for these craft objects to be viewed as small and trivial just because they are produced unconsciously? No, among all the world's handicrafts, the most beautiful and the most numerous are the folk arts, as we can verify with our own eyes. Just as the poor in spirit will one day achieve greatness in heaven, folk art will one day receive, I firmly believe, the honour and respect it deserves.

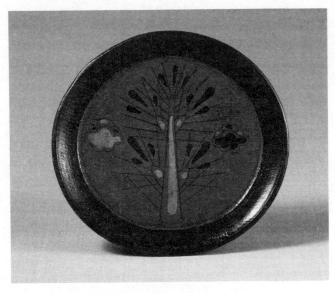

Lacquer tray, pine and plum design.

THE BEAUTY OF
MISCELLANEOUS THINGS
1926

Introduction

There was once a man, poor and uneducated, who was a person of deep faith. Although he found it difficult to explain what he believed in or why, in his simple words there was something luminous, something surprisingly brilliant arising from his experience. He had no personal belongings worth mentioning, but he possessed a deep understanding of what it meant to believe. Without knowing it, he knew God. As a result, he possessed unwavering strength.

I can say somewhat the same thing about the plate now before me. It is nothing more than a simply made object of the type often looked down upon as common and coarse. It displays no overweening pride, no flashy effects. The

artisan who made it gave little thought to what he was making or how it would come out. Just as a Buddhist devotee will continually repeat a religious chant as a means of achieving salvation, an artisan will repeatedly turn a potter's wheel and make identically shaped pieces. Then the same pattern is repeatedly drawn on each piece and the same glaze repeatedly applied. What is beauty? What is the art of the kiln? The artisan knows nothing of that. Still, without knowing all that there is to know, his hands continue working swiftly in the process of creation. It is said that the voice chanting for salvation is no longer that of the believer, but that of Buddha himself. In the same way, the hand of the artisan is no longer his or her own hand, but the hand of nature. The craftsman does not aim to create beauty, but nature assures that it is done. He himself has lost all thought, is unconsciously at work. Just as faith appears of its own accord from ardent belief, beauty naturally appears in works unconsciously created. I never tire of gazing at this plate in front of me.

I

When I refer to the beauty of ordinary everyday objects (*zakki*, or 'miscellaneous things'), you may think I am being intentionally eccentric or perverse. In order to forestall erroneous views and associations like this, I will here list a few cautionary notes. *Zakki* basically refers to the various utensils and tools made use of by the great mass of common people. As such, they could be called *mingu*, 'people's implements'. They are ordinary things that anyone can buy, that everyone comes regularly into contact with in their daily lives. They cost very little and can be procured almost anywhere and at any time. They are familiarly referred to as *temawari no mono* (the handy), *fudan-zukai* (the ordinary), or *katte-dogu* (kitchen implements). They are not meant for display or decoration; they are seen in the kitchen or scattered here and there throughout the house. They are plates; they are trays; they are chests; they are clothing. Largely they are things for family use. All of them are necessary for everyday living. There is nothing unusual

or rarefied about them. They are things that people are thoroughly familiar with, that they know through and through.

II

However, there is one thing that never ceases to amaze me. Though these objects are the most familiar to us throughout our lives, their existence has been ignored in the flow of time, because they are considered low and common. It is as though these beautiful objects had no redeeming features. Even historians, who should be telling their story, are silent. Here I will take up the tale of these common, intimate objects. This will mark, I am sure, the beginning of a new chapter in aesthetic history. Some people will think this endeavour strange and outlandish, but by shedding new light on these objects, the clouds that now obscure the subject will be swiftly swept away.

This raises the question of why these miscellaneous objects have been so long ignored. It is said that someone living in proximity to a flowering garden grows insensitive to its fragrance.

Likewise, when one becomes too familiar with a sight, one loses the ability to truly see it. Habit robs us of the power to perceive anew, much less the power to be moved. Thus it has taken us all these years, all these ages, to detect the beauty in common objects. We cannot be entirely faulted for this failure, however, for we didn't possess the proper distance from these objects to see them for what they were; we were too taken up in simply living among them, too busy in creating them. Conscious appreciation requires a historical hiatus, an interval in time for looking back. History is a record of the past; critical evaluation is retrospection.

The times are now moving rapidly in a new direction. There has perhaps never been an era marked by such radical change. The times, our hearts and minds, and things themselves are flowing by us and hurrying into the past. The weight of custom and convention has been lifted from our shoulders. All before us is becoming new. The future is new and the past is new. The world we were so accustomed to has become an unfamiliar, strange place. All before us, all we see, has become a subject of re-evaluation. It is

as if a mirror has been carefully cleaned and now reflects everything in pristine clarity. The good and the bad all appear as they are, with no distortions. What is beautiful and what is not, the advent of this new age enables us to make that distinction. This is an era of critical evaluation, an era of conscious awareness. We have been given the fortunate role of acting as judges. We should not squander this opportunity.

From the dusty, disregarded corners of life a new world of beauty has unfolded. It is a world that everyone knew, but a world that no one knew. It is my task to speak of this world of miscellaneous beauty, to see what we can learn from it.

III

Things that are used on a daily basis must stand the test of reality. They cannot be fragile, lavishly decorated, or intricately made; such objects will not do. Thick, strong, and durable, that is what is needed. Things for everyday use are not averse to rough handling, and they stoutly withstand extremes of heat and cold. They cannot be flimsy or frail in nature; neither can they be overly refined.

They must be true and steadfast to their use. They must be ready for any type of handling, for use by any individual. Pretentious ornamentation is not permitted; dishonesty of any type is rejected. They must bear every trial and test. Things that don't conform to the rule of utilitarian honesty cannot be called 'good'. In these simple miscellaneous objects, handicrafts are divested of every subterfuge, of every dissembling mask.

This is the world of utility. There is no avoiding reality, no way of escaping it, for the sole purpose of these objects is to serve people's needs. But to think of them as nothing but physical objects would be an error. They may simply be things, but who can say that they don't have a heart? Forbearance, wholesomeness, and sincerity – aren't these virtues witnesses to the fact that everyday objects have a heart? They are rooted in the earth, deeply tied to the earthly life of honest, hardworking people, the recipients of the blessings of heaven. The world of utility and the world of beauty are not separate realms. Who is to say that spirit and matter are not one?

Since these utilitarian objects have a commonplace task to perform, they are dressed, so to

speak, in modest wear and lead quiet lives. In them one can almost feel a sense of satisfaction as they greet each day with a smile. They work thoughtlessly and unselfishly, carrying out effortlessly and inconspicuously whatever duty comes their way. They possess a genuine, unmovable beauty. On the other hand, of course, there is also delicate beauty, beauty that quakes at the slightest perturbation. Yet isn't beauty that remains unfazed by a hard knock or two all the more amazing?

Moreover, this type of beauty grows with each passing day. Utilitarian craftwares become more beautiful the more they are used, and the more beautiful they become, the more they are used. Users and the used have exchanged a vow: the more an object is used the more beautiful it will become, and the more the user uses an object, the more that object will be loved.

These commonplace objects are indispensable to daily life. They are, in fact, our loyal companions, our faithful friends, willing to help out when help is needed. There is not one of us who doesn't rely on them throughout the day. The beauty we see in them is honest and sincere,

an expression of humility. Today, when everything is trending toward the frail and sickly, the beauty we see in these common objects is both a blessing and a joy.

IV

In this beauty there is neither inordinate colouring nor notable decoration. The shape of the objects is simplicity itself, and they are decorated with only two or three patterns done in the most unpretentious manner. They contain no intellectual ambitions or attempts to be stylish. There is not the least effort to surprise or astonish, no straining to overachieve or striving for a particular form; they are simply quiet, calm, and tranquil. On occasion these crafts seem to possess an almost humble, artless mien. They don't try to intimidate or coerce. In a day when the trend is toward showy display, we cannot help but feel a certain fondness for these simple, naive objects.

Most of these handicrafts were produced in obscure, remote villages, or in grungy workshops in the dim backstreets of small towns.

They were most frequently seen in the calloused hands of the poor. These are simple things, made of rough material. They are sold in small shops or from straw mats on the roadside. They are used in cluttered rooms, scattered about. But providence works in strange ways. These same factors have assured these objects of amazing beauty. It is the same with religion, which reveres the virtue of poverty and remonstrates against the sin of pride. This is how such amazing beauty came to reside in such humble objects.

Miscellaneous handicrafts are devoid of ambition. Their purpose is to serve the needs of the people, not to achieve renown. Just as construction workers who have built a wonderful highway don't sign their work, neither do artisans append their names to their ware. From beginning to end, without exception, such handicrafts are made by nameless craftsmen. It is this lack of desire for personal recognition that produces their flawless beauty. Almost all artisans in the past were without academic training. What beauty was, how it came about, they knew nothing of this. They learned the tried-and-true

ways of the past and patiently employed them without the slightest hesitation. There was no need for theory, no need to indulge in sentimentality. The beauty of miscellaneous handicrafts is the result of this single-mindedness, this unconscious devotion.

Since these craftspeople didn't sign their work, it is impossible to trace their history. They weren't artists working on their own but ordinary people, part of the undistinguished masses. That such beautiful objects should appear from the great unwashed, what does this tell us? In the past, beauty was shared by all, not the domain of a few. In the name of the era in which we live, in the name of the country we inhabit, we must commemorate this wonderful work. The ignorant masses, inferior in understanding, were superior in the ways of creation. Now only the individual artist is alive; the age of shared beauty is dead. Previously it was the era that lived, and the individual that concealed his existence. Beauty then was not the province of a few artists, but the home of countless artisans. The miscellaneous things they created became *mingei* – folk craft.

V

Particular attention should be paid to the material used, for good craftsmanship is built on natural foundations, and nature assures the material's quality. Rather than the craft object finding the most suitable material, it can be said that the material finds the right object. Folk crafts are invariably the product of a local environment. When a certain locality is rich in a certain raw material, that material gives rise to a certain craftware. It is these resources, the gift of nature, that are the veritable mother of craftwork. The natural environment, raw materials, and production, these three are inseparable. When they are as one, the resultant craftwares will be natural and free-flowing, for they are the products of nature.

When raw materials dwindle and disappear, there is little choice but to close up shop. Nature is unforgiving when materials are stretched beyond reason. And if material is not available close at hand, how can crafts be produced in mass, both cheap and durable? Behind each object there exists a certain climate, temperature

range, and soil quality, as well as other physical conditions. It is this that adds flavour and colour to provincial crafts, being products of multiple factors. Crafts that adhere to nature receive the blessings of nature. When natural conditions are not satisfied, craftwork becomes weak and dull. The rich quality of common handicrafts is a gift of nature. To see its beauty is to see nature's spontaneous workings.

But this is not all that material affects. It extends its influence to all shapes and all patterns, between which there is an inseparable bond. A good cosmetic finish is not simply applied to an object, but submits to its natural needs. Raw materials must not be thought of as merely physical matter, containing as they do the will of nature. Nature tells us the shape and pattern a material should assume, and nothing good can be achieved by ignoring its dictates. A good artisan seeks nothing that nature does not seek.

This, I believe, is a view worth taking to heart. When one becomes a child of God, the flames of religious faith burn brightly. When one becomes a child of nature, one is encompassed by a natural beauty that only nature can

give. The more one returns to the bosom of nature, the more intense that beauty becomes. In the beauty of common craftware I can't help but find a preeminent example of this precept.

VI

Since these are objects for daily use, they are not hard to find but always available in local markets. Should they get broken, they can be easily replaced by something identical. For that reason they are cheaply produced in volume. Volume you may think unimportant, but actually it has a crucial effect on the beauty of these handcrafted objects. While it is true that mass production may occasionally lead to slipshod work, without it the particular beauty of folk crafts would never be born.

Repetition is the mother of proficiency. Large demand calls for massive supply; massive supply requires repetitive production; repetitive production eventually results in technological perfection. This is particularly true with division of labour, where one skill can be polished to consummation. The process of manufacturing

consists chiefly of this simple cycle, drawing over and over the same pattern, forming over and over the same shape. Those who have mastered these skills are no longer aware of the techniques they use. They have become one with the task at hand, free of all self-awareness and thoughts of artistic manipulation, effortlessly applying themselves to the job at hand. They may be cheerfully talking and laughing as they work, but most surprising is their speed. Speed is necessary if they are to make a living. Thousands of times, tens of thousands of times, it is this repetition that frees their hands from thought. It is this freedom that is the mother of all creation. When I see them at work in this way, I am astonished beyond words. They have complete faith in the power of their hands. There is not a smidgen of doubt. The free flow of the brush, the dynamic formation of the shape, the natural unshackled aura ... Their hands appear no longer to be their own but under the sway of some external force. This is the secret of their craft. Its beauty is the necessary result of mass production.

And these common so-called miscellaneous craftworks are fully mature. They are the

technical consummation of years of endeavour, hard-earned sweat, and endless repetition. This is how their freedom was won. Rather than the products of human hands, they should be viewed as works of nature. Look at the design called *uma no me* ('horse's eye'). No artist, no matter how great, could replicate its easy, free-flowing swirls. They are wonders to behold. In the near future, when everything is made by machine, people will marvel that the human hand was capable of such astonishing feats.

VII

Folk art is necessarily a hand craft. Aside from the hand of God, there is no tool as astonishingly creative as the human hand. From its natural movements are born all manner of beauteous things. No machine, no matter how powerful, can match its freedom of movement. The hand is nature's greatest gift to humankind. Without it, beauty could not exist.

Now, unfortunately, for economic reasons, almost all manufacture is relegated to machines. From these machines there may appear a kind of

beauty, which we shouldn't dismiss out of hand. But this beauty has its limits. We shouldn't rely on it unreservedly, without careful thought. What machines produce is standardized beauty, calibrated and fixed, and beauty built to a standard will remain merely that. Mechanization constitutes a kind of aesthetic strangulation. When machines are in control, the beauty they produce is cold and shallow. It is the human hand that creates subtlety and warmth. How could a machine give birth to the subtle surface elegance that is the lifeblood of folk craft, emerging during forming, trimming, and painting by skilful and experienced hands? Machines only know what has been predetermined, not creative imagination. If the present situation continues, machines will eventually rob work of its freedom, divest it of its joy. In the past, human beings held sway over their tools, and it was this dualistic hierarchy that fostered the crafts and raised them to ever greater heights.

Nowadays, with the era of handmade crafts coming to an end, the miscellaneous things that our forebears created have become precious artefacts. Folk art as a handicraft is slipping into

the past, with daunting conditions blocking its re-emergence. Once folk art has fallen out of favour, the senseless momentum of our times will stand in the way of it regaining its former glory. Only the provinces continue to tread the true path of handicrafts, supported by a small number of fervent individuals. The call to 'return to the handicrafts' will undoubtedly never fade. For it is in the handicrafts that ultimate creative freedom exists, where true beauty is possible. The day will come, I firmly believe, when the miscellaneous things that were formerly the most common craftware will be looked back upon with love and affection. History may falsify, but true beauty can never be false. Rather, with the passage of time, it will shine ever more brightly into the future.

VIII

In the world of folk art, the attitude of the artisans, the quality of the things they make, the techniques they employ, all are extremely simple. This simplicity is required by the character of the things being made. But 'simplicity' must not

be understood as being rough and unrefined. It is this simplicity, in fact, that forms the backbone of folk art. There has rarely been a well-made craft object that was not simple. There are fewer that are complex. True beauty is not possible devoid of simplicity. We call them miscellaneous things, but their simple forms embody genuine beauty. To study the principles of beauty, it is necessary to come to this world, the world of ordinary things known to everyone.

Those who have achieved an enlightened state of mind are free of distracting thoughts; they are at one with their work. Objects crafted in this state of being, where all is entrusted to nature, exist in a liberated zone. There are no unbreakable rules for experienced artisans. Everything is left to the flow of nature, adhering only to the dictates of the object and the heart. Every shape, colour, and pattern is free for use. As for which to choose, there are no fixed rules. Neither are artisans concerned about the exact nature of the beauty that will be the result. And yet there are no mistakes. The choices to be made are not made blithely by the artisans; the free flow of nature does that for them.

It is this freedom that is the mother of all creativity. The great variety and variation found in miscellaneous things is an accurate reflection of this fact. Contrived artificiality does not produce such variety, but rather shackles it. The moment everything is left in the hands of nature is the astonishing moment when creativity begins. Contrived technique cannot give rise to that feeling of freedom; neither can it give birth to such variation. This is not a meaningless cycle, not mere duplication. Each piece is the beginning of a new world, fresh and vivid.

Look at the small cups for dipping buckwheat noodles. The various patterns with which these cups are decorated reach into the hundreds. Who can deny their marvellous brushwork? Even with the ubiquitous stripe-patterned cups, it would be difficult to find two exactly the same. The world of folk art is a world of freedom, a state of imaginative creation.

IX

Since miscellaneous things were made for everyday use and roughly handled, not many of them

have survived from the distant past. Those that have survived are confined to a very few types. It has only been in the last two or three centuries, mostly in the Edo period (1603–1868), that folk art has become diverse. This, of course, includes not only lacquerware and woodwork, but also metalwork and dyeing and weaving, as well as ceramics. These crafts were adapted for use in various types of utensils, furniture, and other furnishings. It was halfway through the Meiji period (1868–1912) that the quality of miscellaneous things began to decline and the true handicraft tradition fell into desuetude. However, in remote provincial areas the traditional techniques and styles are still alive, with not a few artisans still adhering to the ways of the past. Most of the surviving miscellaneous craftware originated in the Edo period and are fairly rich in variety and number.

The culture of the Edo period was dominated by the commoner classes. This is as true of literature as it is of painting. Miscellaneous things were one aspect of this remarkable culture. Like ukiyo-e prints, they weren't delicate, aristocratic works of art but simple common wares with a provincial

flavour. They might not be graceful and refined, but they had the quality of a trustworthy companion. Living with them day in and day out, they took on a warm familiarity. Surrounded by them, people felt comfortably at home.

In general, the history of art began to decline during this period. Works comparable with those of the past became rare. Technique became meaninglessly complicated. Struggling under this burden, handicrafts overall gradually lost their liveliness. They were still meticulously and carefully made, but their heart, the core of beauty wrapped in simplicity, had been destroyed. Trust in nature had fallen under the boot of mechanized technique, and beauty had begun to wither. In the midst of this sad decline there was one art that didn't fall victim to the widespread depredation, the craft of miscellaneous things. Here there were few sources from which the insidious disease could spread. Since miscellaneous things were considered to be outside the realm of art, artisans need not concern themselves with aesthetic concepts. Even in the last stages of this general artistic decay, this craft was the only one in which healthy, wholesome art could still be found. The pieces

themselves might appear rather nondescript on the surface, but they had a presence, an aura, that could rival any finer art. As a test, pick up a miscellaneous piece of pottery and look at its raised foot. Only here will you find a base comparable in strength to that of Chinese and Korean pottery. There is no weakness here. Weakness cannot withstand the rigours of daily use.

X

But this is not the end of the story. Miscellaneous things represent the most original of Japanese arts. In painting and sculpture Japan boasts some masterpieces of which it can be immensely proud, but in general there are few works that have escaped the influence of China and Korea. Rare is the work that can compete successfully in terms of strength and profundity. In the face of the magnificence of Chinese art and the elegance of the Korean, there is nothing that we can unhesitatingly hold up for comparison.

However, when we come to the craft of miscellaneous things, we meet with an exception.

Here we find something particularly Japanese. Here we find solid reliability, overflowing freedom, and unfettered creativity that is neither duplication nor imitation. Among the arts of the world, we can proudly say that this is Japanese. Miscellaneous things are a clear expression of the climate and customs of Japan, its sensibility and way of thinking. They have their own particular Japanese raison d'être.

Some people may feel hesitant to speak of such things as being uniquely Japanese. Abolish the thought from your mind! We should take pride in the fact that the common people of Japan gave birth to these wonderful crafts. We should share in the delight they felt in living side by side with such comforting creations – creations which are not, however, individual possessions, but whose glory is shared by all. The discovery of beauty in these common things is a hard, solid fact. If that were not so, if such beauty were not the foundation of the life of the common people, what an unfulfilling life that would be. I feel it my duty to salvage these wonderful objects from the dust of history for the glory of the Japanese people.

XI

It is one of the mysteries of the world that such great beauty should be found in such lowly objects: that they should come from uneducated hands, that they should originate in remote provincial areas, that they should be the most common type of everyday object, that they should be used in dimly lit out-of-the-way rooms, that they should be uncolourful and made of the poorest materials, and that they should be produced in great number and at low prices. What a mystery it is that the god of creativity should reside in the hearts of these ingenuous artisans possessing no artistic ambition, without intellectual pride, soft-spoken, and happy to be leading poor but honest lives. These same qualities are vividly apparent in the objects themselves.

It is truly amazing that such beauty should permeate these humble objects – objects which devote their existence to service, which sacrifice their lives to the needs of the daily round, which work in the harsh real world without complaint, which carry out their duties with a sense of wholesome satisfaction, and which aim to bring

a little happiness into every life. Moreover, the heavens have ordained that these objects should attain an even greater beauty as they become worn by the handling of human hands. The religious life is also built on sacrifice and service to others. This selfless, devout service to God and one's fellow beings has its equivalent in the service of miscellaneous objects to their users. What an amazing thing it is that objects made for use in real life should possess a beauty that transcends reality.

We have a great deal to learn from those who claim to know nothing about art, who devote themselves unself-consciously to creation, who are unconcerned about renown, and who place their all in the hands of nature, as well as the extraordinarily beautiful things they beget. Just as a true believer does all in the name of God, artisans devote themselves wholeheartedly to their craft. As with the poor in spirit and the humble, miscellaneous things bring true happiness to humankind, and might be called 'children of light' or 'children of joy'. Their beauty is a gift from heaven.

Afterword

The first to recognize the beauty of miscellaneous objects was the first generation of tea masters, men of consummate taste. People have largely forgotten that most of these objects, which are now worth incredible sums of money and are known as *omeibutsu* ('objects of great renown'), were nothing more than common, ordinary, everyday things. In fact, it can be said that it was precisely their commonness, their ordinariness, that produced the elegance of their natural flowing freedom. Without this, they would never have achieved the status of *omeibutsu*. Reflecting on the beauty of the famous *ido* tea bowls, seven particular aesthetic points were noted. Later these points came to be thought of as essential criteria for the creation and appreciation of the beauty of *ido*. But if the original artisans had been told of this development, they would certainly have been utterly amazed. Not surprisingly, there were no works of any excellence created on the basis of these rules. These later pieces had abandoned the realm of craftsmanship and become works of art.

It should not be forgotten that the profound, simple beauty of *ido* tea bowls is the effortless product of common craftspeople.

Nowadays teahouses are built with an emphasis on elegance and taste, belying the original concept of the teahouse as a humble hut. Rustic homes in the countryside still have this simple, honest beauty, a quality which teahouses were meant to emulate. Now, however, teahouses have become embodiments of wealth and affluence, which are signs of present-day decadence. The true meaning of the tea ceremony is being forgotten. The beauty of the way of tea should be the beauty of the ordinary, the beauty of honest poverty.

Historians have given recognition to the most famous tea utensils in their writings, but they say little about miscellaneous things. It is as if nothing existed aside from these renowned objects. However, tea utensils, including tea bowls and other things like tea caddies, form only a small portion of the incredible number of miscellaneous things that have been produced. Their innumerable brother and sister objects, equally beautiful, are still hidden away in dark

recesses, waiting to be discovered. The fact that historians ignore these miscellaneous objects shows that they know nothing about the beauty of tea utensils.

What I would like to do, if it were at all possible, would be to visit abandoned houses in the countryside, salvage their dust-covered tea bowls, and prepare a fresh serving of tea. Doing that, I could return to the roots of tea and commune with the earliest tea masters to my heart's content.

A PAINTED KARATSU AS
FOOD FOR THOUGHT
1926

On November 1, I had stopped eating and was prostrate in bed, suffering from diarrhoea that had struck me the previous night. It was then that a small vessel was brought into the room, and I felt my heart leap with newfound energy.

It was a painted Karatsu jar. The surface was tastefully done, the brushwork for the crest-like circle and the wild grasses excellent, and the iron-black shading unimpeachable. However, what particularly caught my eye was the repair work that had been done on the piece. It was astonishing how much it enhanced the beauty of the jar. I once read an article by an eminent collector in which he rather proudly stated that he didn't collect pieces that had been repaired, but I imagine that if he were confronted with this Karatsu jar, his weak narrow-mindedness would be demolished in an instant. The flaw in the jar had clearly

occurred in the kiln. The piece had been badly split during firing, creating a disjointed gap in the surface. It wasn't a flaw due to a crack that formed when the jar was bumped against something, but one caused by the workings of natural forces. It probably resulted from the base being too thick, a common happening. The flaw was there, no doubt about it, but in effect the jar's flawed form seemed to be its natural shape. There had been no attempt to disguise it, but rather gold-dusted lacquer had been amply employed to repair it. Without the slightest hesitation, lacquer had been liberally inserted into the crevice and gold powder unashamedly applied.

In Zen Buddhism there are such sayings as 'All is clear, openly revealed', and it is this notion that gives this jar vivid life, with the harmony of its plump, round shape and its dark-black fluent brushwork for the crests. However, the piece was not aiming at harmonious elegance. Here the dualism between the beautiful and the ugly was broken. Here the utmost in spontaneous beauty was achieved. This is a living example of the Diamond Sutra's exhortation to 'awaken the mind without fixing it anywhere'.

Recently there is a tendency to pursue distortion in art, but in the case of this jar, natural deformation has raised distortion to the level of spontaneous beauty. Karatsu ware is already highly regarded, and this piece is a precious instance of that craftware. In monetary terms, it was entirely beyond the means of someone like myself. The English word 'priceless' is an apt expression of its value. No matter how expensive it might be, it would still be cheap. The absolute value of beauty makes its relative monetary value meaningless. Still, it had a price that made it, in a pinch, well worth buying for the Japan Folk Crafts Museum. I wanted to bring it to the attention of many people, to give them the opportunity of appreciating its profundities with their own eyes.

However, it will not do to treat an object like this as a mere pastime, for personal viewing, for purchasing, or as a means of satisfying one's desire for possession. There are few objects that provide craftspeople of all types with so much to think about. Is there anyone who would not be lost in thought looking upon this work? From it I received much food for the heart.

I have written this essay in reverent thanks, to which I append a verse expressing my sense of gratitude.

> Look. Oh, look.
> All is clear, openly revealed.
> This countenance, this mien.

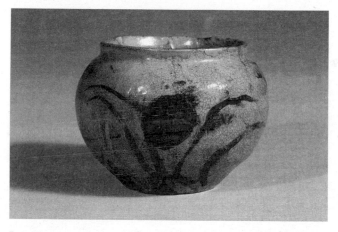

Jar, Karatsu stoneware, underglaze iron, with wild grass motif.

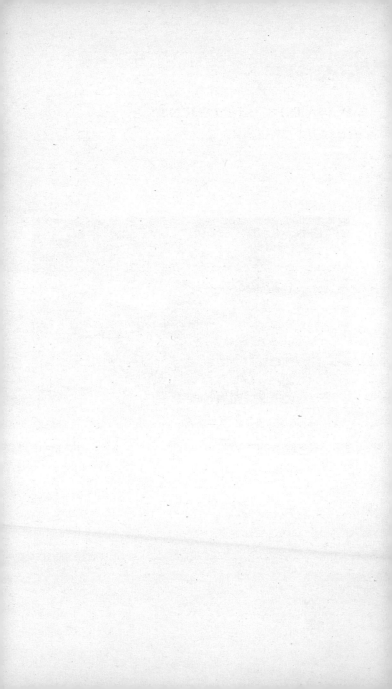

WHAT IS PATTERN?
1932

Introduction

I have always wanted to take up the subject of patterns, but it is such a difficult topic, and my thinking so inadequate, that a great deal of time has fruitlessly passed by. Yet whenever one thinks about beauty, one invariably returns to this subject. To my mind, beauty and pattern are deeply interwoven. Understanding beauty and understanding pattern seem to be one and the same thing. In handicrafts in particular, the bond between beauty and pattern is especially deep. For someone like myself, who holds the beauty of handicrafts in high regard, the matter of pattern cannot be disregarded.

I

Let's start our discussion with a concrete example, specifically with depictions of bamboo grass, which are frequently converted into beautiful patterns for use on family crests. We are so accustomed to seeing bamboo patterns that they may not arouse our interest, but nevertheless I will take them up as superlative examples of patterning. What qualities do these patterns have? In what does their beauty reside? What conditions make for a 'good pattern'?

II

First let's compare real bamboo grass with bamboo patterns. Their principal distinctions are fairly obvious. They resemble one another in that the pattern brings to mind the real thing. They are different in that the pattern is far from being a realistic depiction. The pattern represents reality, but it is also a fabrication.

III

What qualities set off real bamboo grass from bamboo patterns? Real bamboo is a product of the natural world; bamboo patterns incorporate the human perspective. Real bamboo is alive, an organic substance. The human eye endows it with meaning. Without this human input the bamboo remains physically the same, regardless of whether it is seen or not. Anyone can visually apprehend bamboo grass, but the way it is viewed depends on the person. Not everyone perceives the beauty of bamboo in the same way. There are some people who remain unmoved by its beauty, and even if they are moved, it is in a very shallow way. Bamboo becomes beautiful only when it is seen as beautiful. A bamboo pattern is an arrangement made by the human mind. All patterns are the product of human perspective. A pattern is not a realistic depiction of nature but a new creation. Bamboo is a part of nature, but bamboo patterns belong to the human world.

IV

What, then, is human perspective? What exactly is being perceived and how? There are various ways of viewing an object, the simplest of which is intuition. The intellect studies individual parts; intuition looks at the whole. Simply put, intuition is a direct insight into an object's essential nature. When this nature is re-created by the human mind, the result is a pattern. When intuition is weak, the pattern turns into a schematic drawing, nothing more than a cold intellectual composition. When intuition is dull, the only alternative is to add onto, to augment, this artificial composition. Yet in the end, to create a good pattern is to grasp an object's real nature. The fact that patterns have become so weak in our day is evidence of how debilitated intuition has become.

V

A pattern is thus not a depiction of an object as it exists in nature, not a realistic rendition. It is an image of the object as it appears to the intuition.

To borrow one of William Blake's favourite words, it is a child of the 'imagination'. It is not a product of the rational mind and could therefore be called irrational. In a sense, a pattern is an exaggeration. It is not the real thing; it is not a scientific illustration. A bamboo pattern is different from the thing itself, as everyone knows. A bamboo pattern is not the bamboo itself, but rather a symbol representing the bamboo.

Surprisingly, however, this unrealistic pattern evinces the real nature of the bamboo, its bamboo-ness. This insight proves the reality of the pattern. How is it, then, that such an improbable pattern should represent bamboo's inner nature?

A pattern is a depiction of an object's quintessential nature. The truer the pattern is to the fundamentality of an object, the more it captures its life. To the extent that a bamboo pattern encapsulates the life of bamboo, the closer it gets to depicting its bamboo-ness. When intuition sees into the heart of an object, it is seeing it as a pattern. While a schematic drawing on paper is cold and dead, a good pattern is overflowing with meaning. A pattern shows us the

life of things; if it is not alive, it is not a pattern. In that sense, the more unrealistic a pattern is, the closer it is to a faithful rendering, replete with compelling beauty. Its symbolism is not a figment or a fantasy. It might be argued that true symbolism is true realism. A bamboo pattern is the vibrant form of the living bamboo. It is worth repeating again: patterns capture bamboo's essential nature, its bamboo-ness.

VI

Here let us take a look at pattern from another angle. Since a pattern is the depiction of the fundamental nature of an object, it is what remains of an object's form after all that is unnecessary has been removed. In other words, it is a simplification; the pattern emerges when the excessive has been excised and only the essential remains. There is nothing superfluous; it is speech without words, concise and succinct. What has not yet been fully simplified is not yet a pattern. In that sense, patterns are not a form of decoration but an expression of non-adornment. Yet this simplicity must not be interpreted as rough-hewn

elision. In Zen terms, it is 'an all-inclusive void'. It includes all and signifies all. The greater the underlying significance, the greater the vitality. Pattern is movement within quietude, a state in which opposites are one. There is no pattern without quietude; there is no pattern without movement.

VII

Why does a bamboo pattern seem so alive? Simply because it is the distilled form of the bamboo, a depiction of its spirit. In cooking, it could be likened to the flavour produced by slow simmering. A pattern has been simmered down to its essence. A pattern is beautiful because of its compacted, savoury flavour. Pattern is the essence of beauty, form reduced to its primary elements.

To take this a step further, I will go so far as to say that it is impossible to perceive a natural object as being more beautiful than a pattern, just as it is impossible to savour anything more flavourful than a thick, slow-simmered sauce. In a pattern we see bamboo at its most lovely, and

whenever we see a beautiful example of bamboo grass, our thoughts invariably return to the pattern. No matter how lovely, natural bamboo cannot outshine a good pattern, cannot be perceived as being more beautiful. Nature cannot compare to a pattern. When nature is perceived as beautiful, that is because it is being seen as a pattern. Patterns are the crystallization of beauty. To understand beauty and to understand patterns are one and the same thing.

VIII

Since a pattern is a crystallization, it is also an exaggeration. But it is not merely that; it is an accentuation of the truth. Without it, a pattern could not be a pattern. The momentum provided by exaggeration is what lends the pattern its vivid force, a beauty that occasionally verges on the terrifying. Whenever a pattern is particularly beautiful, it invariably takes on an aspect of the grotesque, the result of its being a reinforcement and fortification of beauty. It might be called exaggeration that is faithful to the truth. A pattern does not represent an object as it appears in

nature; rather it is a vivid expression of something that does not, in fact, exist. It is not a realistic rendition; it achieves a state beyond the real world. Only when an object becomes the subject of a pattern does its existence take on an earnest reality. Pattern represents the power and force of beauty.

In the great ages of art there has always been an element of the grotesque, a power that weak, sentimental eras don't possess. The truly grotesque has never strayed far from patternization.

IX

From this we can see that it is only with the advent of pattern that we truly come into touch with the beautiful. Pattern is the conveyor, the transmitter, of beauty. Good patterns teach us how to view nature, how to perceive it. Without patterns, our perception of nature would be far more nebulous and unclear. In patterns we see what is most natural in nature.

Rather than nature giving birth to patterns, it can be more truthfully said that patterns give birth to nature. Patterns represent what is most

clearly seen in nature; they are a condensing of what we see in the natural world. That is, it is through patterns that we are able to see nature for the first time. Nature then appears more mysterious than ever before. An era without good patterns is an era that is not looking attentively at nature.

There is no more striking way of coming into contact with nature than through pattern. Compared to nature in the raw, patternized nature is infinitely more beautiful. Through pattern, nature becomes ever more natural. Pattern represents nature at its most superlative.

X

Why are patterns so beautiful? Patterns are unfathomable purveyors of dreams. Good patterns contain nothing inessential, nothing unnecessary; if they did, they would be drawings from life, not patterns. Patterns stir the imagination; they conjure dreams. The beauty of a pattern depends on the extent to which it liberates the viewer's imagination.

A pattern can be likened to a natural spring.

A spring provides an unlimited supply of water to meet people's needs, never ending, never ceasing to flow. It is the same with beauty, which never ceases to stir the imagination. A beautiful pattern appeals directly to the heart; it is always fresh, always new. Good patterns live in the world of infinite imagination. Beauty intoxicates us by means of patterns. A heart that seeks pattern is a heart that seeks beauty. Pattern makes the world beautiful, just as it makes our hearts and souls beautiful. A country without patterns is an ugly country, a country without beauty. The world is beautified by means of patterns.

XI

Here I would like to turn once more to the characteristics of patterns. The images we recognize as patterns are largely symmetrical. It is difficult for anything that is not symmetrical to become a pattern. Symmetry is, in fact, one of the norms of patternization. Why should this be? Its roots can be found in the deep, dark historical past. The structure of a single leaf, the way a branch is attached to a tree, the form of a petal – all of these

conform to the principle of symmetry. All adhere to a systematic order, and all can be reduced to numerical arrangement, to a strict mathematical code. It is because of this law that balance is achieved. When a certain pattern reaches maturity, we immediately recognize its orderly arrangement. Without this order the pattern breaks down, leading easily to ugliness and disfigurement. Particularly when simplicity is the goal, we realize the importance of numbers, which are most clearly symbolized by symmetry. Symmetry and simplification are two sides of the same coin. The pattern that appears via simplification must needs tread a balanced course. A good pattern adheres to the rule of law; it is not carefree and unprincipled. The beauty of patterns is built on the principles and laws of nature; it is the beauty of numerical symmetry.

XII

Pictures and patterns are generally seen as being different. Pictures are depictions of nature, whereas patterns are compositions devised by the human hand. This distinction is a fairly recent

development; formerly the two were considered indistinguishable. Older pictures and paintings leaned heavily toward patternization, and realistic representation didn't exist. The advent of realism marked a new stage in history. To my mind, however, good pictures are still very patternlike; they are not the obverse of pattern. Pictures that have not reached the level of pattern cannot be considered pictures in the true sense. Pictures must follow the rules and laws of nature; the best pictures live an orderly life. The more closely a realistic depiction adheres to these laws, the more closely it willingly approaches pattern. In the end, a good picture is a type of pattern. The significance of pattern should be recognized in the realm of pictures, even though admittedly this principle is not well understood. Thus pictures tend to move in the direction of patternization, a process that history will undoubtedly pursue in the future. It is no exaggeration to say that pattern represents the essential nature of pictorial depiction. Pictures are not the result of a distancing from pattern but the result of pictures becoming even more picturelike as pattern reaches maturity.

XIII

Why then, in recent times, did pattern and picture go their separate ways? The process was the same as that which divided art from handicrafts, one of the greatest reasons being the emphasis on the individual. Pictorial depiction of late has become an eminently individual enterprise, and individualism has disengaged the picture from the realm of pattern. Pattern, however, as mentioned earlier, follows natural laws, and for that reason it is not individualistic. Often, in fact, certain patterns have become an integral part of a widely shared culture. For instance, Japan has the arabesque and the pine, bamboo, and plum patterns; Korea the peach pattern; Egypt the lotus pattern; Europe the lion pattern; and India the weeping cypress pattern. All of these designs have been developed by a great many craftspeople over a long period of time and been applied to many objects. This surpasses what any individual might hope to accomplish; pattern finds life not in the individual but in the universal. In this way, a pattern achieves a form, and having achieved a form, it becomes ever more widely

used. This is where patterns and pictures created by individuals part ways. In the past, unlike the present, the individual kept a low profile, which is the reason pictures and patterns could be bound together. They contained countless features that were not individualistic. It is not enough to seek for the source of a pattern's beauty in individual eccentricities, for the beauty of most patterns adheres to the laws of nature, superseding the individual. Compared to the power of natural law, individual power is a trivial thing. When pictures are deeply rooted in the laws of nature, they perforce become patterns, and could accordingly be called patterned pictures. The modern tendency to disengage picture from pattern is wilfully wrongheaded. The same applies to the unhappy separation of the arts and the crafts. These events both constitute modern-day tragedies. All of the pictorial images of the past should properly be called patterned pictures.

XIV

Here we can gain a hint as to why pattern and handicraft are so deeply connected. 'Handicrafts'

means crafted objects made for ordinary people, and there is more than one kind of handicraft. The aim of handicraft is the creation of everyday objects for use by the masses. Only exceptionally does it mean the making of luxurious objects for use by the very few. Handicraft takes on a communal function, and it is therefore understandable that it should bond with pattern, which is also inherently communal. Pattern is also universal in nature; it is the beauty of form, as mentioned earlier. Only when it has achieved this form can it truly be called a good pattern. Pictures done in an individualistic style are not suited for use in handicrafts, whose chief feature is that they should be of use to all people. Handicrafts that flaunt their individuality cannot be called good handicrafts. This explains why patterns that live under the laws of nature are more suited to handicraft than pictures that take life at the hands of an individual. Good pattern is pattern that belongs to all the people. Patternization and the handcrafted arts are blood relatives.

The prevalence of painting has grown greater in recent times, all due to the reverence accorded individualism. However, the day will undoubtedly

come when beauty that surpasses individualism will gain even greater esteem. The significance of pattern will be elevated to a higher status, and pictures will become more imbued with the qualities of patterns. There will be, I foresee, a movement from the age of the arts to the age of handicrafts.

XV

What is the force inherent in a good pattern? While patterns are undeniably a product of human skill, the real goal of all skill is to give life to the laws of nature. Patterns are the work of the human hand, but their mission is to make nature even more natural. Skilful patterns are not created as a display of human pride and glory, but as a hymn to the mysterious power of nature. Through patterns and their deep humility and simple modesty, humankind is revealing its devotion to the laws of nature. Patterns can be said to be only indirectly produced by human hands. The more indirect the human involvement, the more direct the role of nature. Looking at a pattern of outstanding quality, we can see that it is not the fruit of frivolous

manipulation; rather it is a means of preventing human error. Mysteriously, by placing artisans under certain restrictions, nature allows them to gain the freedom to create good patterns. This arrangement guarantees that the making of patterns will be a stable, secure process.

What gives pattern its unwavering power? There are various factors, but three are particularly important: utility, materials, and technique. When a pattern adheres faithfully to these factors, the result is without fault.

XVI

The best way to examine these three standards is by means of example. The first is utility, without which a pattern loses its reason for being. In quilted clothing, for example, why are stitched patterns deliberately applied around the collar, the ends of the sleeves, and the hem? It is because stitching provides a means of protecting and reinforcing areas that are prone to wear and tear. It is not mere decoration; it is required by utility, an absolute necessity. While some people may think that necessity is a restriction on

freedom, I believe that these restrictions lend patterns a solid basis for being. The complaints about loss of freedom are made from the human perspective; from the point of view of nature, the loss of freedom indicates what type of pattern is needed for utility's sake. Without the requirements of utility, patterns would be largely meaningless.

Craftwork constrained by utility is often referred to as a suppressed, freedomless art, and is regarded as being of a secondary or tertiary nature. It needs to be understood, however, that this lack of freedom is the ultimate source of handcrafted beauty. Without a clear utilitarian need, there is no guarantee that a good pattern will result. In the realm of handicrafts, utility is the wellspring of beauty. Utility and beauty are not two, but one. All patterns that originate in utility have deep roots.

XVII

Another necessary consideration is material. It is difficult to create a good pattern while opposing the dictates of the material used, but this should not be considered an unfortunate limitation. A

pattern that is rooted in its material is one that is solid and sound. Look at the hand-painted designs applied to lacquerware, for example. These very original designs reflect the special qualities of lacquer. How different they are from the patterns applied to pottery! Even with the technique of resist-dyeing on textiles, there is a huge difference in the patterns produced by stencil dyeing and so-called tube drawing (*tsutsugaki*). If, by ignoring the needs of a given material, you think you can freely create any pattern you desire, you will undoubtedly end up producing nothing worthwhile at all. A pattern must incorporate the qualities of its material; it is that which produces a good match. Patterns created in a carefree, capricious spirit will inevitably meet a sad end. Good patterns welcome material restrictions. It is when we realize this that we recognize nature's constraints as its way of restraining human error. When material matches pattern, the result can never be wrong.

XVIII

The third factor comprising the foundation of a pattern is technique. It is not enough that

patterns be created simply on paper; it is important that they emerge naturally from the technical process. Look at the patterns on carpets, for example. In their essential nature, they are a necessary result of whether they are knitted or woven. They are not the result of caprice, which would produce tragic results. Only when a carpet pattern is created under technical limitations does it become suitable for use on a carpet, attaining the beauty a carpet should have.

Why are the splashed patterns (*kasuri*) of Okinawa so beautiful? The secret lies in the technique called *teyui* (hand-bound). Without this technique, this pattern would be an impossibility. Even if a *kasuri* technique that is only slightly different is employed, the same effect cannot be obtained. This is doubly true if a different textile-dyeing technique is used. This is because technique determines pattern; it is the strictures of technique that of necessity produce the resultant pattern. The fact that absolute freedom is not allowed results in a pattern that is sound and steady. The best patterns owe much to the blessings afforded by this solid reliability.

XIX

When a pattern conforms to the strictures of utility, materials, and technique, its beauty is freed from human error; a good pattern owes a great debt to the helping hand of nature. Put in a different way, patterns are dependent on the grace of an otherworldly power (*tariki*). The greater this force, the more solid the pattern. From this we can understand the extent to which pattern depends on universal laws. The way of the pattern is the way of this transcendent force.

Thus I cannot emphasize enough that the beauty of patterns is the beauty of universal laws. As long as this is true, handicraft cannot be considered the work of single individuals. Human beings are nothing but midwives, seeing that the laws are fully implemented. It is only when they assume this modest role that their work truly shines.

XX

Through patterns human beings come into a world beyond their normal ken. Through good patterns we see the secrets of beauty.

Thinking in this way, we can see that there is a strong bond between pattern and beauty. Creating beauty and creating patterns are not two different things; the issue of beauty cannot be separated from the issue of pattern. Surprisingly enough, this secret principle has not been emphasized up to now, and it is uncertain whether it will be widely recognized in the future. Seeing beauty and seeing a good pattern are indivisible actions. The more profound the beauty, the more closely it approaches a pattern. In one sense or another, all beauty has a patternlike aspect, and that is how it should be.

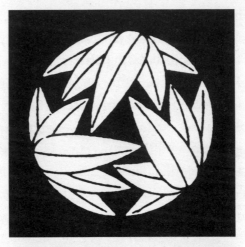

Family crests with bamboo patterns.

OKINAWA'S *BASHOFU*
1939

The islands that stretch from southern Kyushu to Taiwan have long been known to the Chinese as Liuqiu (Ryukyu in Japanese) and to the Japanese as Okinawa. While these islands are rather small and widely dispersed, they have a long history as a kingdom with an exquisite artistic legacy. In terms of land area, there is probably no other island country with such a rich culture. Even the islands of Taiwan and Hainan, though much larger in area, cannot match Okinawa in terms of culture. In literature, architecture, sculpture, music, and handicrafts, Okinawa is incomparably rich.

One of Okinawa's most remarkable achievements is the textile known as *bashofu*, a cloth made from the Japanese fibre banana. An original Okinawan creation, it is used to make everyday kimonos. Look as you might throughout Japan, you cannot find its equal. Look as you might throughout Okinawa, you cannot find a

poorly made example of *bashofu*. Each and every one of them is beautiful. It seems nothing less than a miracle that such natural, wholesome textiles should still be made today. It is strange, however, that while textiles in general are the subject of much discussion, *bashofu* cloth receives little attention. The reason for this is undoubtedly that *bashofu* is the product of small islands far from mainland Japan, and is used mainly for daily wear. Yet anyone cognizant of the beauty of textiles could not possibly pass by *bashofu* without taking a second look. Such a person would be enthralled by the excellence of the materials, the distinctiveness of the design, and the subtlety of the colouring. This person would be amazed that something of such quality could still be produced in this day and age.

The northern part of the main island of Okinawa is called Kunigami, where the village of Ogimi is located. Within Ogimi is the district of Kijoka, which is particularly active in the production of *bashofu*. The cloth used to be made on a large scale in the Nakijin area, north of Nago harbour, but now, in order to see how it is produced, one must visit Kijoka, where every house emits

the sounds of looms. After finishing their work in the fields, everyone is busy dyeing or weaving.

Banana plants form part of a typical tropical landscape. As far as the eye can see, among the cycads, windmill palms, and papayas, banana plants can be seen growing, their broad, pliant leaves fluttering in the breeze. On mountains and in gardens, you can find them everywhere. However, these fruit-bearing bananas are different from the Japanese fibre banana (*ito-basho*), though they resemble one another. The fibre banana, everywhere so ready at hand, is the source of the precious material for making *bashofu*. Inside its watery stems are innumerable rows of beautiful fibres – the nearer the centre, the narrower and more beautiful. First, the overlapping layers of the skin of the plant are peeled and placed in a boiling pot, which contains a mixture of ash. The softened skin is then removed, with only the fibre remaining. This is then dried, and the fibres deftly separated with the fingernails and spun into threads. These are put into a number of boxes. The spinning of the fibres in particular is very time-consuming and labour-intensive. Five or six women gather at one of their homes and do the

work while chatting among themselves. The threads that are produced that day become the property of that household. The next day the women gather at another home, and the results of their work are left at that house. This custom makes this somewhat monotonous work all the more worth doing.

It is said that *bashofu* was originally adorned only with stripes, but that later on patterns in *kasuri* became favoured. The history of *kasuri* in Okinawa seems unfathomably old. Even the highly reputed Oshima *tsumugi* and Satsuma *kasuri* – despite their names appearing to indicate they are of mainland origin – are, in fact, Okinawan in provenance. Kurume *kasuri*, from mainland Fukuoka prefecture, and others like it are nothing but distant relatives. *Kasuri* is a unique product of Okinawa. White *kasuri*, indigo *kasuri*, multicoloured *kasuri*, *tejima kasuri*, and more – no other area has produced *kasuri* of such variety and beauty. *Bashofu* adds to this another level of loveliness. First the patterns to be used are decided. Then threads are prepared for dyeing by tying them with the skins of the banana plant and threads left over from the weaving.

The patterns are those of old, each one of which has been assigned a distinctive name.

Dyeing is done in indigo and brown. In olden days yellow and red were also employed, but now it is only these two. Indigo plants are grown in the nearby mountains. They are especially abundant in Kunigami. Once cut down, they can be easily transformed into dye. In the valleys you will see round holes that have been dug so that small pools of water will form. This is where the basic material for the dye is produced. It doesn't take long to obtain a thick base; the warm climate is suitable for this. From this point on it is not difficult to make the dye. All that needs to be done is to put the liquid in a crock in a corner of the kitchen to ferment. This process presents none of the difficulties indicated in the saying that the indigo of the old province of Awa needed a virtual doctor of science to manage the fermentation. That such a beautiful colour should result from such a simple process is all but miraculous. On the mainland, anything not touted as being 'natural indigo' is not trusted, indicating the lamentable conditions prevalent there. Fortunately, this phenomenon has not yet reached

Okinawa. In Okinawa natural indigo is the norm, and nothing to boast about. This is a blessing we can be thankful for.

Brown is obtained from *tekachi* trees (*Rhaphiolepis umbellata Makino*) that have been felled in the mountains. The roots, trunk, and bark are all usable. They are boiled to obtain a thick soup in which the threads are soaked. A mordant is unnecessary.

When the dyeing is finished, the thread is woven on a loom. The woven cloth is then completed by boiling it again. This process is not suitable to cold weather; a hot, humid climate is required. It is almost as if Okinawa were created for the making of *bashofu*. In the village of Kijoka every grandmother, wife, and daughter is adept at this work; everyone can thread, bind, dye, and weave. The village has about 200 households, all of them busily engaged in making *bashofu*. There can't be many villages like this still existing on the earth.

Amazingly, there is not a single bad piece to be found among the specimens produced here. It is unlikely that you could find a similar case anywhere else in Japan: not a single example of bad

work, every one of them a result of natural processes. For those of us whose job is to critically distinguish the good from the bad, Kijoka is a different world, a place where it is impossible to produce bad work when certain conditions are met. It is a veritable textile heaven. It is only by coming here that one can witness this miraculous truth.

This brings to mind the weaving factory in Yuki, Ibaraki prefecture. Renowned for its superlative work, it apparently still adheres to the use of the traditional *jibata* loom, hand-spun thread, and natural indigo. Its cloth is extremely expensive, but there are always buyers. It boasts the highest quality. Still, Yuki and Kijoka are different. Yuki must compete with the cheapened rivals around it, trying its utmost to maintain traditional ways. What with selection of the proper materials and the best dye, as well as the care lavished on the weaving of patterns, this cannot be done cheaply. It goes without saying that volume is limited. Those who buy this expensive cloth are restricted to a small number of wealthy individuals who appreciate its quality. It is made by a few and purchased by a few – a very precious item.

Bashofu is a different story. The materials, the dye, all can be found nearby. There is no question of choice because there is only what there has always been. The spinners and weavers are only doing simple, repetitive work; there is nothing unusual about the designs. This means the cloth can be produced cheaply and made in plentiful quantities. *Bashofu* can be made by anyone in the village; it is nothing unusual. There may be some difference in quality, but even the bad is good.

The users of *bashofu* cloth are ordinary people, not the wealthy. It is used for the kimonos they wear every day. It is not something they buy with a highly appreciative aesthetic eye, comparing one piece with another as objects of art. It is bought as a mundane item and worn as a part of mundane life. Still, *bashofu* is beautiful just as it is. Here the idea that you get what you pay for does not apply. The cheap is the good and beautiful. It is cheap and beautiful because natural conditions made it so.

Comparing *bashofu* with Yuki cloth, we can see how free, easy, and natural it is. The cloth made in Yuki is highly commendable, but *bashofu*

is even more worthy of praise. Any work that requires conscious rather than natural effort is taxing and time-consuming; such conditions lead to undesirable, exorbitant prices. Society cannot be proud when a product is available to only a select few. Neither can clothing that is worn only on special occasions be considered a social ideal. Equating the expensive with the beautiful cannot be a point of pride.

Most surprising is that something made for ordinary use should be so beautiful; that such marvellous work should naturally result without paying particular attention to every aesthetic detail; that such superlative, cheap cloth should be so readily available; that an anonymous handicraft should be so exquisite; and that such wonderful cloth should be made for daily use.

These amazing qualities are exactly those found in *bashofu*.

Bashofu is used to make cool summer clothing in Okinawa. It should be more widely known on the mainland, where I am sure it would be welcomed. It is much more suitable to summer than hemp. There is a secret to its washing, however, which requires a bit of acid.

In addition to summer clothing, *bashofu* could be used in other ways: for example, as mosquito nets and on summer cushions, as well as on sliding doors (*fusuma*) and as wallpaper. I would like to see it used as book covers.

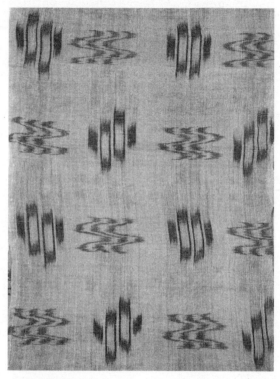

Bashofu cloth.

THE BEAUTY OF KASURI
1959

The word *kasuri*, written with the Chinese character 絣, originally meant 'a plain silk cloth'. Now this character is read *kasuri* in Japanese, derived from the verb *kasureru*, meaning 'to rub'.

The *kasuri* technique of resist-dyeing was thought to have originated in India, but recently various examples of what appear to be *kasuri* have been discovered from the Han dynasty, revealing that the technique also existed in China. However, it is not certain how the character 絣 was pronounced in Chinese. We also have the character 纃 meaning *kasuri*, but it is said to have been coined in Japan. Such characters as 飛白 ('spattered white') are simply common means of expression that have gained popularity in China. As for Europe, the fact that the word *ikat* entered European languages from the southern islands of Java and Sumatra would seem to show that the technique didn't exist in

Europe. In France, *kasuri* is called 'Chine', indicating that the French thought the technique came from China.

So it seems, in any event, that *kasuri* came to Japan from the south, first reaching Okinawa where it flowered before spreading to the mainland, leading in the end to Japan becoming the foremost country for the production of *kasuri*. At one point it reached every nook and cranny of the country, with almost every Japanese dressed in indigo *kasuri*. Its heyday was undoubtedly the period from the latter part of the 19th century to the early part of the 20th. Everyone of my generation wore it when young. There was probably not a single household that didn't have one or two pieces of clothing in indigo *kasuri*. This popularity led to a number of production centres devoted to its manufacture. From south to north, there was Okinawa first of all (the main island of Okinawa, as well as Miyako, Yaeyama, Kume, and others); then Amami Oshima (Kagoshima pref.), Kagoshima (Kagoshima pref.), Kurume (Fukuoka pref.), Iyo (Ehime pref.), Bingo (Hiroshima pref.), Hoki (Tottori pref.), Izumo (Shimane pref.), Yamato (Nara pref.), Omi (Shiga pref.),

Noto (Ishikawa pref.), and Echigo (Niigata pref.), in addition to other famous localities. A good deal of *kasuri* was also undoubtedly produced in the households of obscure farming and fishing villages around the country. At first the standard cloth was that for an adult kimono, which was decorated with fine patterns, but later on nightwear and other clothing was made with bolder patterns. The patterns ranged from simple stripes to complex pictorial designs. The material included cotton, hemp, and silk, and in Okinawa also *bashofu* and *tonbian* (orchid fibre). Most were indigo *kasuri*, but there was also white *kasuri* (Yamato, Omi, and elsewhere), brown *kasuri* (Kurume), and multicoloured *kasuri* (Okinawa, Yonezawa, and elsewhere).

As mentioned above, *kasuri* initially began in Okinawa and then spread in response to overwhelming popular demand. Different types of resist-dyeing are used prior to dyeing the thread, but whether the thread is tied or bound by hand, stencilled, or placed between engraved boards, they all share one feature with respect to pattern: the edges of the patterns don't exactly match. Both in the dyeing and the weaving of

the thread, there is some misalignment. The resultant blurry effect makes it seem as though the pattern has been rubbed or smudged, giving rise to the name *kasuri*, 'rubbed'. *Kasuri* is thus a textile that appears to have been rubbed. Since the edges of the pattern do not align, they take on the nature of an odd number rather than an even number. Without this rubbing or smudging, *kasuri* could never have been. However, since it is precisely this misalignment and blurry effect that is the source of *kasuri*'s beauty, we are presented with an interesting problem. I will call this problem 'the beauty of odd numbers'.

In one sense, it can be said that the fact that the pattern edges don't align perfectly is due to human ineptitude, to a lack of mastery of the technique. In another sense, given that the result is the same regardless of who undertakes the task, it can be said that some deeper process is at work, that this nonalignment is an inevitable natural outcome, that the smudging and rubbing of *kasuri* is nature taking its course. That is, the *kasuri* effect is a technique originating in nature, not a human manipulation.

This is strikingly similar to the blurring

effect that occurs in calligraphy as a result of natural processes, not as an intentional human augmentation. Interestingly, the fact that this adds immensely to the beauty of calligraphy evinces the power of nature as opposed to human contrivance. Consequently, if one were to try intentionally to produce this effect, the result would, conversely, be unnatural and result in a loss of beauty, the upshot of going against nature.

In any case, it is not an exaggeration to say that the nonalignment of patterns seen in *kasuri* is a natural phenomenon of amazing beauty. In fact, one might ask: Which is it that contributes more to the beauty of *kasuri*, nature or the human hand? For the sake of argument, marshalling all available human intelligence and expertise, let's say that perfectly aligned patterns could be produced. Let us then compare this with natural *kasuri*.

Once, when visiting Okinawa, I had the opportunity to see an example of *kasuri* that had belonged to the royal Sho family and was renowned for its incomparable quality. According to what I was told, this piece was one of a number that had been made at the behest of the

government of those times, with the strict stipulation that the patterns be arranged so that there would be no blurring. Even to produce this one piece must have been an arduous task for the binders, dyers, and weavers. Examining it, I saw that there was hardly any blurring. The patterns were accurately aligned in almost perfectly straight lines. This piece, created at the behest of the highest authority, had undoubtedly received great kudos as something that could never be done again.

Looking at the piece, though I could see that it was exquisitely made, it seemed hard and cold, lacking in warm beauty. It had largely lost *kasuri*'s special flavour. True, it had been made with painstaking care and was a technical tour de force, but there was no hiding the fact that it had lost its life as *kasuri*. The patterns were so clear-cut that they could have been made with a stencil. The piece had reached the point where it could no longer be called *kasuri*. Defying nature, it had become very unnatural.

As I closely examined the piece I became aware of an interesting problem lurking within it. As mentioned earlier, there is a blurriness in

the patterns of *kasuri* by its very nature, a mis-alignment. Since this is a matter beyond technical control, it can be thought of as a type of human error, a human blunder. From nature's perspective, however, it falls within the natural course of events. *Kasuri* should not be thought of as the result of human ingenuity but as the product of the mysterious workings of nature. While it can be said that the superlative piece belonging to the Sho family is an exceptionally fine accomplishment produced by human hand, it can also be said that the wonderfully blurred effect of normal *kasuri* is an amazingly fine craftwork produced by nature. Comparing the two, the latter is by far the better. That is, *kasuri* that looks like *kasuri* is the overwhelming winner in this contest; the *kasuri* that is not *kasuri*-like is found to be wanting in both life and beauty. Comparing them, normal *kasuri* far exceeds the piece declared superlative by government officials. This will certainly be the final judgment handed down in the Kingdom of Beauty.

Perhaps this interesting, intriguing, perplexing problem can be perceived in the following way. In the process of production, *kasuri* comes

under various technical restrictions. When the threads are bound together, no matter how tightly they are tied, no matter how carefully they are gathered, the process is subject to variation because it is done by hand. Then, when it is dyed, there will be a difference in permeability according to the thickness and firmness of the thread: sometimes it will be deeply dyed, sometime shallowly. There will also be differences in the density of the dye. Starting with the binding and dyeing, these technical limitations lead to events beyond human control. Next, when the thread is placed on the loom, a second stage of restrictions goes into effect. Because of slight differences in the movements of the loom operator's hands, there is a slight difference in the alignment of the pattern's edges. This leads inevitably to the blurring of the pattern.

Although people are inclined to think that this blurring is merely a result of technical ineptitude, it will simply not do to assign what is a natural, necessary outcome to human error. *Kasuri* is the unavoidable outcome of natural forces.

Looked at in another way, since craftspeople cannot bind, dye, and weave free from all

restriction, it stands to reason that their work has to be effected within the limitations placed upon them. While this means that craftspeople may be under the impression that their work is restricted and restrained, it also means, conversely, that they are beneficiaries of the freedom afforded by nature. Human restriction is nature's freedom; this is the essence of *kasuri*, its origin. To understand this truth more fully, think of the artist who in unshackled, unrestrained freedom creates a pictorial design. Some good pictures will result from this endeavour, but also a great many that are unsightly. Since humans are imperfect beings, they cannot wholly escape from committing mistakes.

However, let's look at the state of standard *kasuri*. To my way of thinking, the case is entirely the opposite of the above: as long as *kasuri* adheres to standard procedure, almost nothing is produced that is positively ugly. Why should this be? The reason lies in the fact that many of the techniques involved are carried out under the aegis of nature, leaving little room for human error. The Sho family's superlative *kasuri*, hard and cold as it is, is an egregious example of what

happens when nature is purposely opposed. In standard *kasuri*, on the other hand, there are few ugly pieces because their emergence has been suppressed by nature.

It can be said that while creating *kasuri*, the artisan is working in a state blessed by nature. The beauty of *kasuri* is received as a gift. As long as the laws of nature are upheld, the beauty of *kasuri* remains intact. This demonstrates the curious principle that the artisan is deprived of technical freedom but works in the freedom of nature.

In this sense, *kasuri* can be said to be created in a state of freedomless freedom. Conversely, when artisans throw off all restriction, they can be said to be in a state of free freedomlessness. This results from the human tendency to oppose nature and stray from universal laws. The superlative work in the Sho family is a perfect example of this. In the end, the beauty of *kasuri* is the beauty of the laws of nature. Ugly *kasuri* becomes a virtual impossibility as artisans enter a world essentially devoid of human error. In this case, seeing is believing, for no matter who does the weaving, the result will be exquisitely the same.

Of course, even in standard *kasuri* there will be some difference in quality, but there is no *kasuri* that is obviously ugly. If there is, it is the result of not adhering to the laws of nature. But there is one thing here that needs attention. While the blurry effect is the essence of *kasuri*, excess impairs the beauty of the cloth. The reason is that, with excess, the mathematical balance is disrupted and disharmony ensues. It is the same with calligraphy. If, thinking that a blurry effect is good, you employ it to excess, the beauty of the lettering will be lost in the end. Beauty requires balance and degree. Excessive *kasuri* ruins the beauty of *kasuri*.

Here I would like to present one more instance showing that *kasuri* is an art adhering to universal law. In Okinawa there is the technique called *teyui* ('hand-bound'), in which bundles of thread are placed at mathematically determined intervals. Almost all older Okinawan *kasuri* employs this technique, producing all the relevant patterns. Interestingly, however, it is not possible to create just any type of pattern using this technique. There are limitations; only patterns based on certain fixed intervals can be

created. That is, patterns falling outside of the mathematically determined boundaries are not feasible. One step too far and the pattern is disrupted and becomes meaningless. In that sense, stringent restrictions apply to this technique. Yet, on the other hand, it was under these restrictions that the beauty of Okinawan *kasuri* was born, a phenomenon of unlimited interest.

Later, however, in the Meiji period, a new method called *iji* ('picture sketch') was developed in Okinawa. This was entirely different from anything done before, and it permitted a certain degree of freedom in pattern creation. For one thing, it allowed for mathematical restrictions to be ignored. Thanks to this, Okinawan *kasuri* became much freer – or so many people thought.

However, when *kasuri* done by *teyui* and *iji* are compared, one overwhelming difference appears. As mentioned earlier, while the *teyui* method produces next to no obvious unsightliness, the *iji* method produces hardly any apparent beauty. Why should this be? Why should there be such a disparity between the two? It boils down to this: whereas standard *kasuri* using the *teyui* method is based entirely on mathematical

principles, the *iji* method is based on human whim. The former is protected from error by nature, while the latter is prone to human error. This is what decides the aesthetic stability of the two methods: the first being surefooted and based on universal laws, the second founded on human freedom and liable to instability. Standard *kasuri* strides down a safe, broad road, while *iji* treads a narrow path with many dangerous curves. This is what leads to the huge difference between the two.

In my opinion there are two principal factors accounting for the beauty of *kasuri*. One consists of the blessings of nature (not to be interpreted as human error), which produce the blurred *kasuri* effect. The other is the steady stability produced by a reliance on natural law. It is the combination of these two factors that produces the incomparable beauty of standard *kasuri* created by the *teyui* method and mathematical principles.

In conclusion I would like to touch upon one more fundamental truth: no matter who engages in the process of making *kasuri*, all are essentially equal. Particularly with the *teyui* method,

there is little difference between those who are eminently capable and those who are not. The reason lies in the fact that *teyui* is founded on the laws of nature, not on human capability. In this sense, *kasuri* relies on a power that supersedes the individual.

We can see from this why *kasuri* is essentially free of human error. The work is conducted under the aegis of nature, which precludes mistakes by human hands. When observing the extremely simple and clear-cut *teyui* method and other such activities as they are being carried out, we see this surprising truth in action. We see it in the work of the Okinawan women who, though they may be illiterate, all produce wonderful *kasuri* in their designated tasks. This makes this truth all the more clear. I have never seen a poorly made example of Okinawan *kasuri*. They have all been saved from the sin of ugliness, as it were, and appear to us in their redeemed forms.

Since indigo *kasuri* ceased being the normal clothing of ordinary Japanese, its value has gradually been forgotten, but I still believe, for the following reasons, that *kasuri* is the most important of the Japanese textiles.

1. It is the most highly developed of Japanese textiles.
2. It was once the normal wear of all Japanese, and the traditional techniques with which it is made still survive.
3. It is a unique Oriental textile virtually without precedent in the West.
4. It possesses phenomenal beauty.
5. It treads a safe, broad road following the laws of nature.

For these reasons I consider *kasuri* to be one of the most important, unique, and beautiful of Japanese handicrafts, eminently worthy of protection and further development. Particularly today, when the Japanese people are bent on copying whatever they can from the West, the need to preserve this unique technology is all the more important.

While there will undoubtedly be some people who will dismiss *kasuri* as a labour-intensive, time-consuming manual craft from the past, there will also be some, tired of modern mechanization, who will rediscover in *kasuri* a new freshness and beauty. Moreover, the day will

surely come when the world assesses this unique Oriental textile at its true value. Especially now, when abstract beauty is being viewed with a new regard, there will undoubtedly be many who are captivated by *kasuri*'s abstraction. It seems to me that, among the textile arts, the beauty of *kasuri* cannot be denied, that it is a handicraft of paramount importance.

I will be immensely pleased if this special issue of *Mingei* creates a greater appreciation for *kasuri*.

By rights, I should have dealt here with the closely interrelated indigo dye in more detail, but I am afraid that that big subject must be put off for another day.

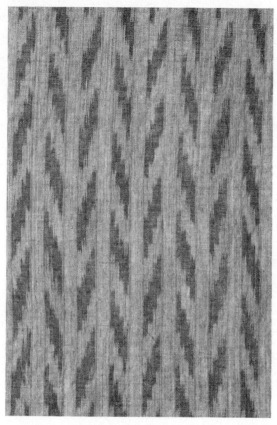

Kimono with white arrow *kasuri* pattern (detail).

THE CHARACTERISTICS
OF *KOGIN*
1932

The photograph on page 138 shows an example of *kogin* from Tsugaru in northern Japan. The word refers to the quilted clothing (*sashiko*) worn by both women and men in that area. I am pleased that I have been given the opportunity to speak of *kogin*'s particular beauty. In place of writing a preface to this issue, I will briefly record some of my thoughts about the special qualities of *kogin*.

I

In winter Tsugaru is ravaged by blizzards. Mountains, trees, and houses are defenceless against them; their force is irresistible. With the coming of the snow, life out of doors becomes untenable in Tsugaru. The sense of oppression is overwhelming. When the wind blows, the

cold becomes almost painful. The snow piles higher and higher. With the coming of October, the snow-laden sky grows gloomy. After the passing of autumn, what follows is depressing winter. Nights are terribly long. The skies don't clear until the arrival of spring in April, so half of the year is buried in relentless snowfall. It might be more appropriate to say that life itself is buried. How is this endless period of time to be spent? Outdoor work in the fields is replaced by indoor work in the home. Under the snow's reflected light creeping into the houses, beneath the dim lamplight, various types of manual work are taken up. This is how time is forgotten; this is how work absorbs the hours and days. If time remains unused, winter becomes a curse. Yet there is work to do, work to be done with the hands. Once this work begins, the clock no longer measures the passage of time. *Kogin* is a product of this snowbound country, a product that has forgotten time. *Kogin* is not the fruit of a hurried life. It is one of the blessings of nature, revealing a profound connection between snow and work that is done with the hands.

II

Kogin is one of a kind – impossible to replicate anywhere else, unique to Tsugaru. It is the product of nature, history, and human endeavour, though times have changed between now and then. The textile called *kogin* is the outcome of fateful elements, of the workings of karma. It could not have come into being in any other country. It is the supreme example of a Japanese regional handicraft.

The *kogin* tradition is already dead, however. Once dead, the chances of it being revived are thin, for it was the product of special circumstances. Tsugaru is still the same. The relentless snow still falls. But the women who made *kogin* now find themselves in different circumstances. This should come as no surprise. It is work they would like to continue, but nonetheless *kogin* seems fated to fade into history. It will survive only as a memory. Its beauty, however, will never perish. Its beauty will still be one of a kind.

III

Poorly made *kogin* does not exist – not a single piece. Look as you might, there is none to be found, though there may be some differences in overall quality. There are also some differences in the patterns. But there is no *kogin* that can be called poor. Why is that? It is not a deep, dark secret. *Kogin* is made according to strict rules. It is as simple as that.

All *kogin* patterns are created with horizontal and vertical threads. The stitcher faithfully follows the stitches of the cloth. If this is not done, the result is embroidery, not *kogin*. The horizontal and vertical threads follow a strict order. It is only by adhering to this order that *kogin* can be produced. It follows, in effect, a numerical formula. If this formula is breached, the pattern will be thrown into disarray. If followed, the result will automatically be the desired pattern. No matter which stitch is picked up, if the numbers match, the effect will be beautiful. Number is the ultimate wellspring of pattern. Relying on its power, the resulting patterns will be solid and steady. There is no risk with *kogin*.

Whoever makes it, whichever woman is the creator, beauty is the inevitable outcome. This is because they are following the traditional ways. It is not that these women have some special power. It is because they submit to the rule of numbers that such spellbinding results are possible. People nowadays are always in a hurry in their search for freedom, and it is this hurry that robs them of the freedom to create *kogin*. When unsightliness results, it is generally because the rules of the craft have been slighted. The rule of numbers and the beauty of *kogin* are one.

IV

To be snowbound throughout the winter must have seemed a cruel fate at times. But *kogin* itself was not considered a curse. It provided the opportunity to experience the joys of creation. If *kogin* were, in fact, a curse, such wonderful work would not have been possible. To make *kogin* was a sign of womanhood. It was a source of pride for young girls, for the mother of the family. It provided an opportunity for friendly rivalry; otherwise, the results would not have

been so painstakingly made. In this monotonous work, they forgot all monotony. They loved what they were doing. Without this love, they couldn't have been loved themselves. The merits of a young woman could be seen in the *kogin* she made. From an early age, daughters learned how to create lovely *kogin* at their mother's knee.

Kogin patterns were likely the subject of frequent discussion. The local names for each pattern have come down to us today. How were these patterns to be combined, how many patterns were known and could be put to use? Women were tested on these points, and their answers to these questions can be seen in the variety of work they produced.

Wearing their *kogin*-enhanced clothing, both men and women set out to take part in the liveliness of the town, whether during times of special celebration or during local festivals, adding vividness and cheer to the holiday atmosphere.

V

How did this type of embroidery come into being in one lonely corner of northern Japan? Who first

thought of it? According to documentary evidence, the clothing of the native inhabitants of Ou (now the Tohoku region) consisted of indigo hemp. Quilting was used to mend places in need of repair, making use of available white hemp to carefully stitch tears and holes. Visually, these seemingly random patchings formed recognizable patterns. When edges and borders were mended, they formed nice outlines. If the stitching was done all at one time rather than piecemeal, the hemp became strong and durable. All that was necessary was to pick up the right stitch, which, in and of itself, produced a proper pattern. It took time, but it was perfect work for the long winter days and nights. And once finished, it was an object of general praise. From one person to another, over a long period of time, this tradition was passed on and enhanced. And when cotton made its appearance, this was another cause for local joy. By stitching cotton onto hemp, the cold hemp became warmer. Over time this work became the province of women and a source of pride. The history of *kogin* is the history of utility being transformed into beauty.

In their work, these women were faithful to

the ways of the past. They didn't make random or frivolous changes. No matter how painstaking the work, they faithfully picked up one stitch after another. They revered tradition; in consequence, they never went astray. The beauty of their work had its roots in utility and adhered to the law of tradition. The wholesome beauty of *kogin* is *kogin* itself. Wholesome beauty is what makes a handicraft a handicraft.

VI

Kudos to the unsung women of Tsugaru for leaving us such beauty! Cotton and hemp constituted the exclusive cloth of these northern farmers, for they had been forbidden the use of silk by government fiat. But even under such heavy restriction, beauty was born. Was this a happy accident or an accidental happiness? In any case, through their own efforts these people made their daily lives more beautiful. This is the true calling, the mission, of handicrafts. We are drawn by that beauty, and we have much to learn from it. *Kogin* is not a woven art; it is an embroidery unique to Japan. Living at a great distance from that northern

country, I feel blessed to have met up with such beauty. Most of its creators have passed on to a happier place. Being poor women living in obscure villages, they now sleep under the snow, with no one to visit their graves, no one bearing flowers when spring comes around. In place of such mourners, I would like to dedicate this short essay to these women. I would like each word to be a memorial to the creators of *kogin*. Together let us memorialize the work they did. Those who feel as I do, who would like to place flowers from the heart on their graves, will grow in number in the coming years. This is the *kogin* that never dies, the genuine *kogin*.

Kogin, hemp and cotton. Tsugaru (detail).

THE JAPANESE PERSPECTIVE
1957

I

Recently the National Museum of Modern Art in Tokyo published a monthly periodical titled *The Modern Perspective* and held an exhibition under the same name.

Looking at the periodical, I discovered that, in fact, it was about Western perspective. It seemed to be saying that the Western perspective was the modern perspective, or that the modern perspective was the Western perspective, and I couldn't help feeling mightily displeased. I asked myself why a museum located in Japan shouldn't advocate the Japanese way of looking at things. Why it shouldn't show what was best about the Japanese perspective, point out what was lacking in the Western view, and indicate how the one could augment the other. Even the way in which this museum arranges artworks for display is

frequently merely an exercise in copying Western fads. There is a lack of imagination.

Though I am ill in bed at the moment, I decided to write something about this periodical and lodge a protest. I couldn't help feeling that Japan should have more confidence in the Japanese way of perceiving things, and that it should make this more widely known to the world. While there is no need to be foolishly pompous or self-aggrandizing, the time has come, I believe, for Japan to confidently present its own view. Do people think the Japanese perspective less sensitive than the Western? Do they feel that Japan should humble itself as being retrograde and less than modern? In my opinion, the Japanese way of perceiving things is richly endowed with many profound, insightful aspects that are not fully developed in the West. And this aesthetic is not composed of makeshift elements cobbled together on the spur of the moment.

Japan has learned many things from the West, beginning in the Meiji period in the mid-19th century, and there is undoubtedly still much to learn. This applies especially to science,

a field in which Asia has fallen behind. Of course, if we succumb to the fallacy of thinking that science is almighty, we may lose more than we gain. There are many instances where the riches of mechanized civilization have had adverse effects and deserve careful consideration and thought. The United States is perhaps the most outstanding example of a mechanized country, but still many of its citizens are suffering from stress and feelings of angst. The fact that tranquillizers are in such demand there is a reflection of social disease. As rich as it is, America is perhaps unrivalled for its vulgar lack of propriety and decorum, which may account for its having the world's highest crime rate.

It is fine to learn what one can from abroad, but by taking it to the point of idolization and adulation, Japan runs the risk of losing its cultural identity. It is fine to speak with pride of having a modern outlook, but if this simply means borrowing a Western perspective, there could be nothing more pathetic. Why does everything 'modern' have to be seen through Western eyes? At this rate, what is Asia's raison d'être, what is its justification for being? Does

Japan have to live constantly in emulation of others? No, not at all. A century has passed since the Meiji period, and it is about time Japan divested itself of Western hero worship and began returning some of what it has received. To my way of thinking, this can be done in two major ways: one is through the teachings of Mahayana Buddhism, the other through the special qualities of Asian art. In neither realm has the West shown much sign of development.

A remarkable recent phenomenon has been the interest taken in Zen Buddhism by Western philosophers. Just lately I read the following, the words of a preeminent modern Western thinker, Martin Heidegger. He said, 'If I had come into contact with the works of Daisetsu Suzuki on Zen at an earlier date, I could have reached my present conclusions much sooner'. In addition to Zen, there is also the thought of the Kegon school and the concept of *tariki* (the 'power of the other'), both of which would be innovative concepts for Christian countries. In the realm of the arts and crafts, the art of empty space seen in the Nanga school of monochrome

painting and the abstract, free-flowing art of calligraphy have already begun to exert considerable influence on the West. Just as occurred in the case of the Chinese sculpture of the Tang and the Six Dynasties, the profundity of the art of Asia will inevitably receive greater recognition. Even now, Chinese pottery produced by the Song kilns is avidly collected and studied by Western museums.

Asian art represents a latent treasure trove of immense and wide-reaching value for the future, and that is precisely because it presents a sharp contrast to Western art. For example, compare Rodin's *The Thinker* with the statues of the Miroku bodhisattvas at Chugu-ji and Koryu-ji, which present these differences so clearly. Even though they are somewhat similar in form, the contrast between agonized thought and quiet meditation couldn't be more pronounced. Both are transfused with deep meaning, but *The Thinker* gives no indication of the final end of humankind as do the Buddhist statues. It is the principle of quietude seen in the Mirokus that Westerners should reflect upon.

II

So what does Japan have to offer the world from its corner of Asia? There are many aspects to this question, but in my opinion the most significant offering we can make is the Japanese aesthetic, its eye for beauty backed by a long history of development. This ability to see through to the underlying beauty of things should receive much more attention.

Generally speaking, the Western perception of art has its roots in Greece. For a long time its goal was perfection, which is particularly noticeable in Greek sculpture. This was in keeping with Western scientific thinking; there are no painters like Andrea Mantegna in the East. I am tempted to call such art 'the art of even numbers'. In contrast to this, what the Japanese eye sought was the beauty of imperfection, which I would call 'the art of odd numbers'. No other country has pursued the art of imperfection as eagerly as Japan.

I once read a discourse on art by Wassily Kandinsky in which he took a highly favourable interest in the Japanese word *e-soragoto* ('art

[picture] is fantasy'). The word refers to the quest for truth that goes beyond truth; it refers to the art of imperfection, the art of odd numbers.

This Japanese perspective first began to take conscious form in the Muromachi period (ca. 1336–1573) with the advent of Noh drama and the tea ceremony. Of course, the tea ceremony has its critics, and some even go so far as to say that tea is an old, musty way of thinking. But, in fact, as a highly original 'path' to art appreciation, it contains much that is profoundly original. Even in global terms it represents a rare way of perceiving beauty, has deeply influenced the life of the entire Japanese nation, and forms the aesthetic foundation for all Japanese today. It cannot be denied that, to one extent or another, our aesthetic education owes much to tea.

Just as Western art and architecture owe much to the sponsorship of the House of Medici during the Reformation, tea and Noh owe much to the protection of the shogun Ashikaga Yoshimasa (1436–90). Yoshimasa may not have been an astute politician, but he loved art passionately. It was he, together with the Ami family of artists

and the tea master Juko (?–1502) working under his protection, who created perhaps the most brilliant era of Japanese culture, the Higashi-yama period (1443–90). Later, the tea masters Joo (1502–55) and Insetsu (dates unknown) also played an important role. In the background Zen priests such as Ikkyu Sojun (1394–1481) were active, giving tea a more profound Buddhist base. This led to the phrase 'Zen and tea are one', indicating how tightly Zen and the tea ceremony were bound together – probably the first time in world history that art appreciation and religious thinking were so intimately interfused.

III

What, then, was the fundamental principle underlying the beauty of tea (*chabi*)? As fortune would have it, it was not an intellectual concept, but rather consisted of concrete objects that acted as intermediaries – the teahouse, the garden path, the utensils. It was these that allowed the tea masters to plumb the depths of beauty. Concepts such as *wabi* and *sabi* had appeared in the previous period in reference to literature, but

with the flourishing of the tea ceremony they began to be used in reference to concrete objects. Literally, *sabi* commonly means 'loneliness', but as a Buddhist term it originally referred to the cessation of attachment. The ultimate Buddhist goal was the achievement of the fourth Dharma seal – 'Nirvana is true peace' – through the cessation of self, the cessation of greed, and the superseding of dualism. Ultimately, the beauty of tea is the beauty of *sabi*. It might also be called the beauty of poverty – or in our day it might simply be called the beauty of simplicity. The tea masters familiar with this beauty were called *sukisha* – *ki* meaning 'lacking'. The *sukisha* were masters of enjoying what was lacking.

Thus the beauty of tea was not the pursuit of unerring perfection. In fact, Tenshin Okakura (1862–1913) called it the beauty of imperfection. Shin'ichi Hisamatsu (1889–1980) went a step further and called it the rejection of perfection. But I think it goes beyond the dualistic thinking of perfection or imperfection; borrowing from Zen terminology, I would call it natural (*buji*) beauty, the beauty of everyday life (*byojotei*), of egoless freedom (*muge*). It is not a clinging to

the duality of imperfection or perfection; it is the beauty of absolute freedom.

While imperfection in the form of deformation can often be seen in tea bowls and other utensils, this is not an intentional distortion but an expression of the love of unhindered freedom. There is no true deformation that does not follow the laws of necessity. In later years, when deformation came to be consciously created, when the rejection of perfection became a matter of deliberate manipulation, the true meaning of tea began to be lost. As I see it, the true path came to an end with Joo, and by the time of Sen no Rikyu (1522–91) and his style, tea had come to be categorized into a number of fixed formulas, marking the onset of its downfall. By clinging unwaveringly to the forms of tea, the freedom of tea was lost. True tea must be selfless tea (*cha misho*). To put it in somewhat contradictory terms, true tea existed only before the advent of the tea ceremony. After the coming of tea, when deformation came to be consciously sought, common everyday beauty disappeared and unnatural manipulation began. This meant the demise of the beauty of tea. In the recent West,

potters have been avidly pursuing 'free form', which in actual fact is nothing more than a regurgitation of post-tea manipulation. There is no way this will produce true freedom. What the Japanese perspective sought was natural beauty; nothing more, nothing less. No matter where you look abroad, you will find nothing comparable. In modern Western art there is now a strong tendency to seek the strange and extraordinary. But it lacks a sense of solid significance; there is something pathetic about it, something painful and distressed. This is a result of a penchant for the diseased and perverted, not for the wholesome and healthy.

IV

Here I would like to say a word about the character of tea utensils. As I wrote above, tea is not repelled by cracking and distortion but rather sees them as a new source of beauty, an expression of freedom. Nowadays, the West has become very conscious of deformation, and almost all of its modern art intentionally incorporates it in some form or another. Yet this same deformation

has been a part of the art of tea for over 400 years. This Japanese perspective, which doesn't hesitate to find beauty even in cracked ware, is without parallel anywhere in the world.

Of course, if this is taken to an extreme, the ordinary form of an object will be violated and the original meaning lost. It is said that tea masters would sometimes break a bowl on purpose and then have fun mending it. This is going a bit too far, I think, even though it is a result of the tea masters' insight into the nature of beauty. It might be seen as a deleterious effect of this perspective and something to be guarded against. Nevertheless, it was the tea masters who first discovered the beauty of deformation, and they are to be honoured for their originality and insight. This tradition is still ingrained in the Japanese eye for beauty, permeating the Japanese soul after decades of training. It is an appreciation of art that is free and unhampered. Deformation represents a quest for beauty that goes beyond the limitation of fixed forms.

I have many friends, but for quickness of perception my Japanese friends generally stand out head and shoulders above the rest. Even among

young Japanese there are some with very keen eyes. Bernard Leach (1887–1979) once had this to say: 'If you find something good in a Japanese secondhand utensils shop, you have to buy it immediately, because if you go back the next day, it will be gone'. He was expressing his admiration for the quickness and perception of the Japanese eye. In Britain it seems the shop would be visited a number of times before a decision was made. This is not bad, but it shows the extent to which Japanese quickness is acknowledged. While not always perfectly logical, perhaps the Japanese make up for this failing in their daily lives by keen intuition.

Next I would like to take up what it means to 'see'. While everyone, of course, sees, there are many ways of seeing, so that what is seen is not always the same. What is the proper way of seeing? In brief, it is to see things as they are. However, very few people possess this purity of sight. That is, such people are not seeing things as they are, but are influenced by preconceptions. 'Knowing' has been added to the process of 'seeing'.

We see something as good because it is

famous; we are influenced by reputation; we are swayed by ideological concerns; or we see based on our limited experience. We can't see things as they are. To see things in all their purity is generally referred to as intuition. Intuition means that things are seen directly, without intermediaries between the seeing and the seen; things are comprehended immediately and directly. Yet something as simple as this is not easy to do. We mostly see the world through tinted glasses, through biased eyes, or we measure things by some conceptual yardstick. All we have to do is look and see, but our thinking stands in the way. We can't see things directly; we can't see things as they are. Because of our sunglasses, the colour of things changes. Something stands between our eyes and things. This is not intuition. Intuition means to see immediately, directly. Something we saw yesterday can no longer be seen directly; it has already become a secondhand experience. Intuition means to see now, straight and true; nothing more or less. Since this means seeing things right in front of you without intermediaries, it could be called 'just seeing'. This is the commonsensical role of

intuition. In Zen terms it might be expressed by the saying, 'One receives with an empty hand'.

Considered as a form of activity, the seeing eye and the seen object are one, not two. One is embedded in the other. People who know with the intellect before seeing with the eyes cannot be said to be truly seeing. This is because they cannot penetrate beyond the ken of the intellect and achieve perfect perception. There is a huge difference between intellectual knowledge and direct intuition.

With intuition, time is not a factor. It takes place immediately, so there is no hesitation. It is instantaneous. Since there is no hesitation, intuition doesn't harbour doubt. It is accompanied by conviction. Seeing and believing are close brothers.

In the realm of seeing intuitively, the Japanese are particularly blessed. This is due, as mentioned above, to the nationwide education afforded by the tea ceremony. Every country, according to its historical and geographical conditions, has its own peculiar character. India is characterized by intellect, China by ready action, and Japan by aesthetic perception – the three splendours of the

East. Indians are adept at thinking, Chinese at acting, and Japanese at appreciating art. In Europe, France is close to Japan, Judaism to China, and Germany to India. In Germany, however, the intellect tends to be philosophical rather than religious.

While there may be many intrinsic contradictions, I still think that there is probably no country like Japan whose people live in surroundings composed of specially chosen objects. Behind it all is undoubtedly some sort of educated taste or standard of beauty. Of course, some aspects may be shallow or mistaken, but in any case things are chosen according to some standard. This may be something as simple as *shibui* or *shibumi* (simple, subtle, and unobtrusive beauty), a concept which has permeated all levels of Japanese society. It is hard to tell to what extent this simple word has safely guided the Japanese people to the heights and depths of beauty. It is astonishing, in fact, that a whole nation should possess the same standard vocabulary for deciding what is beautiful. This is due entirely to the laudable achievements of the way of tea. Even people of the flashiest sort know in the back

of their mind that *shibumi* is a class above them; they may even feel that, as they grow older, they themselves will one day join its ranks. Among the recent seekers after the new and novel, there are those who consider *shibumi* to be old and out-of-date; this is not a fault of *shibumi*, however, but just a matter of personal preference.

Shibumi is not wandering or drifting between the new times and the old. It contains something that resides outside of time, a truth that is always new and fresh. It harbours a deep Zen significance. It represents a natural beauty that the Rinzai sect of Zen described with the word *huji*. Since it is not a fabricated beauty, it is not lost in the comings and goings of ephemeral fads. The Japanese sense of beauty is bolstered by a profound backdrop, something not to be found in the West. Without doubt it will contribute to new cultural developments in the future, for it has the power to augment the failings of Western culture. The Japanese people should take pride in their aesthetic eye and make it more widely known. It is worth noting that, even in the East, Japan is the only country possessing a standard aesthetic vocabulary consisting of terms like *shibumi*. In the realm

of aesthetic appreciation, even China and Korea lag behind. One might go so far as to say that the true appreciation of the art of Japan's two great Asian predecessors is best done by the Japanese. Strangely, the ones to first seriously study Korean art and realize its great value were Japanese, not Koreans. Here we can see the workings of the Japanese eye. For that reason, Japanese museums should play a more active role in highlighting Japanese taste. This can be easily done without borrowing Western perspectives. Furthermore, the artistic displays should be carried out according to Japanese principles. If this is done, the eyes of the world will be struck with amazement.

In a very small way the Japan Folk Crafts Museum has been trying to fulfil this mission, to unreservedly highlight the Japanese aesthetic perspective. There is no blindly following Western ways. There is no being led astray by 'modern' perspective. In consequence, there is an endless stream of foreign visitors. In fact, I should like to see the Japanese eye be elevated to the level of an 'eternal' eye. This is not impossible. There is no need for the Japanese eye to pursue fads or fashion. It is deeply rooted in Buddhist thinking and

represents an intuitive quest for the truth. If circumstances permitted, I would one day like to build a museum in the West arranged on Japanese principles. To bring the Japanese perspective into the light of the world is, I believe, a cultural mission that we cannot ignore.

V

Above I discussed the insights inherent to the Japanese perspective by referring to the art of odd numbers. Here I would like to say something about the beauty of *muji* ('no ground'). *Muji* essentially means a ground that is plain, solid-coloured, and unpatterned. There is virtually no tradition in the West to revere such beauty. In ceramics, for example, the majority of Western objects are patterned and multicoloured, with the patterns playing the most prominent role. The Japanese view, on the other hand, has largely sought the beauty of the plain and the unadorned as its ultimate goal.

This perception has its distant roots in the Buddhist precepts that all things are empty of intrinsic existence (*ku*) and that all is void (*mu*).

The appreciation of *muji* may be simplicity itself, but at the same time it involves the highest level of sensibility. The Japanese interest in *muji* grew in step with the burgeoning of tea. Ultimately, *wabi*, *sabi*, and *shibumi* are different approaches to *muji*. In the field of ceramics, it hardly needs to be said that the country that has produced the greatest number of *muji* ceramics is Korea. This is not a result of a tradition of infusing Zen and tea as in Japan, but the outcome of Korea's history and natural environment. The number of monochrome pieces in white or black glaze is stupendous. There are no intricate designs featuring a multitude of colours. From the beginning, Korean ceramics seem to have been fated to be detached from the world of colour. The same is true of Korean textiles, which are undyed. Everyone wears white clothing. Koreans don't even have the custom of enjoying colourful flower arrangements or toys. However, it would be superficial to think of *muji* as simply a lack of colour. Rather it is an expression of the limitless existence (*yu*) that is encompassed by the void of *mu*. In terms of Noh theatre, it is movement within quietude, quietude within movement. It is an example of the infinite

riches to be found in a life of honest poverty. Or it is a concrete representation of 'Emptiness exactly is substance' from the Heart Sutra. While Japanese love *muji* pottery, the West has no particular fondness for unglazed ware or its close equivalents. Those who love tea bowls will automatically turn over the bowl to check its raised foot, which is generally unglazed and rough, revealing the texture of the clay. It is a source of unrivalled pleasure. This holds especially true for areas where the glaze is thin and uneven, which are called *kairagi* ('sharkskin'). This type of appreciative assessment is unknown in the West. One of the principles of tea propounds the value of roughness as well as quiet appreciation. 'Roughness' refers to naked and raw places without glaze or sheen, which are perceived as overflowing with flavourful subtlety. Here we can see the insight and profundity of the Japanese eye for beauty. Here is the reason tea masters valued Bizen and Iga ware so highly. They represent a kind of naked beauty, a beauty without artifice. This lack of glaze and sheen also accounts for the appeal that 17th-century foreign *namban* pottery held for the Japanese. Interestingly enough, even as much as

200 years ago, the beauty of Bellarmine stone-ware was highly appreciated in Japan.

The keen attention given plain *muji* ware is one of the characteristics of the Japanese perspective. It is not an exceptional case, however, but inherent and fundamental. Someday Western students of art will come to realize this. It could be expressed by saying that the plain is the best. There is also the Zen saying, 'The inelegant is also the elegant'. In the plainness of *muji* can be seen an infinite variety of patterns; 'plain' does not mean that nothing is there. Here I would like to append three lines in praise of *muji*.

A pattern that is not a pattern is a true pattern.
Create patterns until they are no longer patterns.
The true pattern is a patternless pattern.

When creating a pattern, one's heart must also be *muji*. A pattern must be followed through until it is no longer a pattern. It is a true pattern only when it has ceased to be a pattern. Forgetting the void of *mu* and lingering in the world of existence (*yu*) will not produce profundity.

Among tea utensils, Karatsu ware is revered

for its simplicity of design, a lingering sense of *muji*. On the other hand, work like that of Non-omura Ninsei (17th century), with its colour and elaborate designs, is several steps removed from the tea ideal. Tea masters were particularly fond of 'brushed' (*hakeme*) pottery, and detected in the traces of the brush an infinite subtlety. These traces might be called the quintessential *muji* pattern. White monochrome clay is unaffectedly applied, and the path of the brush spontaneously creates a pattern, a patternless pattern. This also accounts for the fact that the essentially plain *yohen tenmoku* was so widely revered; unadorned, it is infinitely adorned. Raku ware and suchlike consciously pursued this type of beauty. Of course, Raku tea bowls are largely *muji*, though they are given infinite variety through the use of glaze. *Ido*, the king of tea bowls, is without specific pattern, but it does have a rich design owing to small imperfections in the glaze, throwing, clay quality, and firing.

Notably, all the tea utensils the tea masters loved were, as a rule, of the *muji* type. The Asian concept of *mu* that gave birth to this beauty deserves to be brought to the attention of the

world. Some day in the future the West will undoubtedly welcome this magnificent gift. *Muji* can alternatively be called simplicity. In religious terms it might be likened to the virtue of honest poverty, a poverty that is replete with riches. The beauty of *muji* is the beauty of poverty. 'Roughness' and 'quiet appreciation' characterize this beauty.

It has not been my intention in the above to belittle the decorative nature of Western ceramics; there is much that is superlative there. From a Japanese viewpoint, however, the best Western pottery is that which contains a certain simplicity in its decorative effects. When there is an element of *mu* hidden within, their beauty becomes ever more profound. Flashy effects alone are not enough. Their effectiveness depends on how much *mu* they contain. *Mu* remains the most important, the deepest, the most fundamental of artistic principles. Japan should, I think, make a gift of this principle to the West. This is the heavy burden, the mission, that the beauty of *mu* must bear. Together with the beauty of odd numbers, it forms the bedrock of the Japanese sense of beauty. One day the West will discover the

infinite originality of this principle. As a Japanese, I feel both a sense of pride and mission in bringing it to notice. All Japanese should join in this worthy endeavour.

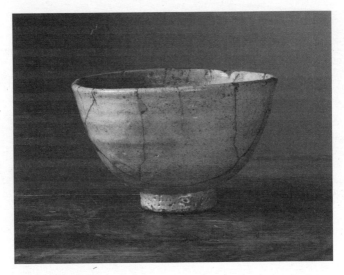

Ido tea bowl.

THE STORY BEHIND THE
DISCOVERY OF MOKUJIKI
1925

I

Here I would like briefly to answer some questions I am frequently asked about the Buddhist priest and sculptor Mokujiki. How did I come to take him up as a subject for study, how did I go about it, how did I arrive at my conclusions concerning him? I would like to respond to these issues.

I arrived at the point where I am today by a curious fate. Until quite recently I was completely ignorant about Mokujiki, just like everyone else. It just seemed that the proper time had come, that what was fated to happen finally happened. It was not as though I chose to study him, but rather that I was chosen for the job. It is as simple as that.

However, looking back, I can see there were several preparatory stages leading to my

169

fascination with Mokujiki. (It was not, mind you, that I finished these preparations all at one time; it was more a matter of accumulative degree.) Here I will mention three of these stages. For a long while I have striven to acquire the ability to discern real beauty by educating myself, and I have finally reached the point where I can trust my intuition. (My belief in intuition as the fundamental element in judging beauty has become unshakable.) I have reached the point where I cannot spend a day of my life divorced from the world of beauty. Fortunately, my mind has become very quick in this regard, allowing me to discover at least a few types of beauty that were previously unrecognized. (It was also the quick and intuitive movement of my mind that led to my writing a biography of William Blake ten years ago, and to my efforts to preserve the arts of the Korean Joseon dynasty several years back.) The moment I first saw the amazing work of Mokujiki, my soul was instantly enraptured. There was not the least hesitation or doubt in my mind. In a letter to a friend, I couldn't help writing, 'Mokujiki is the greatest sculptor of the early 19th century – the late Edo period'. I

found his work that amazing. Rather than me having discovered Mokujiki, it was as though he had discovered me.

The second stage of preparation was due to the fact that I had recently become thoroughly enthralled by folk crafts. I had come to feel that real beauty, and the principle for creating it, lay in things made for everyday use, things that had been created unconsciously without any aesthetic theory, that had emerged from poor farmhouses and remote village workshops, that were eminently provincial, local, and of the people, things that had seemingly emerged fully formed from nature without artifice. (Presently, I spend my spare time collecting these so-called ordinary everyday things from local kilns and making plans to announce the results of my findings in upcoming papers and exhibitions. In doing this, I believe I can bring this amazing world and its heretofore hidden beauty to a wider audience.) In consequence, it goes without saying that I was strongly moved by Mokujiki's sculpture and its extraordinary folk art flavour.

The third preparatory stage was that my field of specialization is religion. I have been

particularly drawn by the extremes of religion. (The two or three books I have written on the subject, as poor as they are, may serve as a narration of the life I have led until now.) As it happened, the fundamental nature of the religious life I had been seeking was vividly embodied in the work of Mokujiki. I could not but be intensely moved. Being strongly attracted to a world in which religion and art were tightly interwoven, I felt myself being irresistibly drawn toward his work, which seemed a perfect union of the two. In an age when religious art has withered and dried, meeting up with Mokujiki was equivalent to stumbling across an oasis in the desert.

These, then, constituted the preparations I had made. However, what put these preparations into motion can only be called destiny. It was something beyond my control. A person is placed in a certain position in life, but he has not placed himself there. That is the work of an unseen, infinitely greater power. What brought Mokujiki and me fatefully together was not my individual effort. It was a blessed gift, something greater than myself.

A momentous event occurred on January 9, when I was visiting Yamanashi prefecture on a whim. For one thing, I wanted to visit Seizo Komiyama and see his Korean ceramics. For another, I hoped to take a stroll around Hino-haru and enjoy the winter scenery afforded by the mountains Yatsugatake and Komagatake. I also had it in mind to buy some local handicrafts. The one who had invited me to take this trip was my esteemed friend Takumi Asakawa. We left on the eighth and disembarked from the train at Kofu. A walk of some four kilometres brought us to the village of Ikeda, but unfortunately Mr Komiyama was not at home. With no other choice, we stayed a night at nearby Yumura. Early the next morning, the ninth, we made our way to Mr Komiyama's home once more.

That day was the first time for me to meet Mr Komiyama, and also by chance the first time for me to see a Mokujiki statue: in fact, two statues. I say 'see', but it was more a matter of the statues leaping into my eyes. The first thing Mr Komiyama showed me was the pottery I

had requested to see, not the statues. The statues – one of Jizo bodhisattva and the other of Amida – were situated in front of a dark storage room. My gaze inadvertently touched upon them as I passed by. (If they had happened to be covered by a piece of cloth, Mokujiki and I might never have met!) I was immediately spellbound. Their smiles irresistibly drew me in. This was not the work of an ordinary sculptor. It could only have been created by someone who had an extraordinary religious background; that is what my intuition told me. As I was shown into the drawing room, there was another statue, this time of Kukai. It was then that Mr Komiyama first uttered the name Mokujiki, adding that he was from the Kyonan area in Yamanashi.

Seeing my astonishment, Mr Komiyama also seemed moved; he offered to make me a gift of one of the statues and have it delivered to my home. It is hard to describe the joy I felt at this act of kindness. Some sixteen days later the Jizo statue arrived, wrapped carefully in a straw mat. I had caught a cold upon returning from the trip and was confined to bed. I had the statue placed

near the head of the bed, where I was once again entranced by its smile. (Who could possibly resist that smile!) Enthralled by its mystique, I couldn't take my eyes off it. (If I had not been sent this statue, perhaps I would never have undertaken my present research. Dormant feelings were suddenly set aflame. I will never forget Mr Komiyama's kindness in providing this opportunity.) It was on that day that I became determined to devote myself to the study of Mokujiki.

From that day on, I spent every day and night with the statue of Jizo. How often and how long I gazed at it, I really don't know. No one who came to visit me in my room could leave without admiring it. One and all were enraptured by its smile. With the passage of time I gradually became enveloped in its mysterious world. I began to correspond with Mr Komiyama, asking him many questions. For his part, he used his many connections to send me as much information as he could. As a result, I gathered some basic facts: that Mokujiki was from the village of Marubatake, Kyonan, Yamanashi prefecture; that he had made dozens of

statues for a temple there; that the temple was still extant; and that he had been active around the Kansei era (1789–1801). I also learned from Shiko Muramatsu of the former Ichikawa Daimon-cho that there was still a monument to a Mokujiki Kansho in the area, as well as some documents written in his own hand. He further expressed the opinion that Mokujiki Kansho and Mokujiki Gogyo (another of Mokujiki's names) were without doubt the same person.

What I needed most of all was some sort of documentary evidence, but no matter where I looked, no matter what Buddhist dictionary or compendium of famous people I examined, I found nothing. I even looked through histories devoted particularly to Yamanashi prefecture. Still, there was not a single mention of Mokujiki. Even Matsudaira Sadamasa's detailed and voluminous *Kai kokushi* (Record of the Kai Domain; 1814), a topographical study of the Kai domain (now Yamanashi prefecture), was silent on Mokujiki. I also looked into the *Nishi Yatsushiro gunshi* (Records of Nishi Yatsushiro County; Yamanashi prefecture), but found nothing, even though it is a recent publication. All the local

histories tended to note each and every detail; still, I could find no mention of Mokujiki. It seemed that I would have to find firsthand evidence on my own. At the time I didn't know if this was even possible. But there seemed to be no choice: I would simply have to go myself and visit the area where he was born and raised. Keeping this thought in mind, I waited for an opportunity to carry it out. In the meantime I was so fortunate as to see more than twenty Mokujiki statues in Tokyo.

Without realizing it, the time to begin seriously studying Mokujiki was fast approaching. In April of that year, the Korean Folk Crafts Museum, which I had been working on quietly for the last four or five years with the support of the Asakawa brothers, was finally nearing completion. We displayed the entire collection in a space provided within Gyeongbokgung Palace in Seoul, the facility was opened, and the first stage of my work came to an end. (I say 'first stage' because this work is essentially endless!) Thus it transpired that I was able to focus all my energy on research into Mokujiki.

Then, as it happened, I lost my older brother

in an earthquake and for the sake of the family was forced to leave Tokyo for Kyoto. I was obliged to cancel all lectures in Tokyo, and in consequence all my time became free. While it was somewhat reckless from an economic point of view, I also gave up all new work in Kyoto with the idea of devoting myself entirely to Mokujiki – I had become that besotted with his work. For one year I lived and breathed Mokujiki. (One person commented that my Mokujiki research was only possible because I had the time and money to do it. But that misses the point, I think. It is not time and money that enables one to search for the truth. It is not time and money that drives a passion for doing research on someone like Mokujiki. Still less would it beget the energy for such work. As it is, I don't know many people with money and time on their hands who are devoting their lives to spiritually satisfying work. In my case, I wasn't doing this work because I had an abundance of free time; I was doing it in spite of having no free time. I gave up everything but this one thing.) Thus it was that the bond between myself and Mokujiki became ever tighter.

III

Exactly a half year later, on June 9, 1924, my hope to visit Yamanashi again was realized. I spent the first night in the village of Ikeda; the next day, together with five or six other people, I went to Ichikawa Daimon-cho to examine the monument to Mokujiki. My doubts that there was any connection between the sculptor Mokujiki and Mokujiki Kansho grew, and were confirmed in the end. I was disappointed at first, but the birthplace of the sculptor Mokujiki was only about thirty kilometres down the Fujikawa river. I parted with the group at Kajikazawa and walked alone along the river in the setting sun. I stayed the night at the village of Itomi, and on June 11 I finally reached Marubatake, Mokujiki's birthplace. At Hadaka-jima I left the boat I had taken partway and arrived at Shimobe. There I was fortunate to obtain the services of a guide and trekked up the Tokiwa river for about eight kilometres. Winding our way along the mountain path under the warm noonday sun, we became drenched in sweat.

Until that day I hadn't been certain what area

Marubatake belonged to. I didn't know whether the people living there were related to Mokujiki by blood, or if there were any artefacts surviving from the past – it was all a mystery. Turning left at Nagashio village and climbing a steep slope, we arrived at the hamlet of Namisawa. This was the Tomisato division of Marubatake, where I had been told there was a household Buddha statue made by Mokujiki. What I was suddenly shown was a statue of the bodhisattva Kannon with a horse's head on top, a *bato kannon*. As I gazed at it, for a moment I nearly lost the ability to breathe. Once again I had come face to face with Mokujiki's original means of expression. Next to emerge from the sooty Buddhist altar were several statues and a votive tablet. The puzzle that had been tormenting me now began to become clear. I was then led along a winding path to the house where Mokujiki was born. My heart was bursting with expectation. Surrounded by curious eyes, I asked one question after another. The local people had their hands full trying to respond to this stranger in their midst. I busily took notes, determined not to miss a word of their testimony. Gradually

Mokujiki began to take form. One thing that bothered me, though, was the temple that was said to house a number of Mokujiki's statues. I visited the site, but the temple had long ago disappeared. As I paid my respects, I noticed a stone marker that had been abandoned in the grass. Returning to where the relations were gathered, I tried to get some answers to my remaining questions. What I wanted most was some sort of firsthand documentation, but on that point they didn't have anything to offer. The sun was beginning to go down, and I decided to abandon my hopes for documentation and started to leave, asking one last time if there wasn't something by Mokujiki's own hand. It was then that a young farmer produced some tattered papers and said, 'It should all be written here'. In the dim twilight I took the papers and began to read. The first lines said, 'Originally, I the bodhisattva Mokujiki Gogyo', and the end of the document bore Mokujiki's seal. There was no doubt that this was the writing of Mokujiki, in fact his autobiography. I still remember the exhilaration I felt then. It was impossible for me to leave without making a copy. After repeated requests the

villagers finally acquiesced to my pleading, and it was decided that I should make a copy that night. They kindly offered to make room for me to stay. Hungrily I began reading the papers. There weren't that many, but the unfamiliar calligraphy, the large number of words written in katakana and hiragana, and the stylistic differences made for hard reading. Having pored over the document, I then had to carefully copy by hand each and every character. By the time I laid down my brush, the sky had begun to grow light.

In the meantime something happened that I will never forget. The document mentioned that Mokujiki had carved the Five Dhyani Buddhas for a local shrine, and when I inquired about them, I was told they still existed. I decided to go and check them out immediately rather than wait for daylight to come. Under lamplight I set out for the shrine, which I was told had no live-in priest. The creaking of the doors as I opened them sent a surprisingly loud echo through the nearby hills. As I stepped into the dilapidated interior and raised the lantern high, out of the dark from the centremost of five alcoves there appeared, like an unexpected phantom, the face

of the Buddha. I let out a cry of astonishment, and at the same moment the four statues on either side of the central Buddha emerged from the darkness.

Around six that morning I returned the manuscript as promised. It was then, quite unexpectedly, that a portable box that Mokujiki had shouldered on his travels was produced for my inspection. This event turned out to be the genesis of Mokujiki research. Within this box, unopened and unseen for decades, were the answers to the mysteries of Mokujiki's being. Precious documents and manuscripts appeared one after another – a record of temples visited (*nokyo-cho*), a list of inns stayed at (*oyado-cho*), a collection of *waka* poetry, and more. The box, covered in dust and grime, had been sequestered in this isolated mountain village for over a hundred years. You can imagine the astonishment and joy I felt when I opened it and examined each item. My visit to the village had been repaid many times over.

However, a careful examination of this much material could not be done in a day or two. Knowing this full well, I returned to Kyoto to

make the necessary preparations. Without wasting a moment of time, I made my way back to Marubatake three weeks later. That was on July 3. The purpose of the trip was to borrow all the documents and undertake the first step in Mokujiki research. As it happened, our negotiations with the villagers met with some obstacles. Fortunately, I had brought along testimonials for myself and three others in my party, stamped with official seals. With these in hand and repeated explanations, we managed to reach an agreement. Our group of five or six people had left for Marubatake early in the morning, but the sun had already set by the time the negotiations were finished. Carrying the reference material, we made our way back to Shimobe. (During the negotiations, the mediation provided by Mr Ishibe and Seizo Komiyama will not be easily forgotten.)

As a result of these two trips, the basic materials for commencing research on Mokujiki were in place, and I was now able to start my studies based on documents written in Mokujiki's own hand. My hopes and expectations had begun to take shape in very favourable circumstances,

thanks to the fact that these materials included what might be termed his autobiography, a sort of travel journal, discourses on religious doctrine, and *waka* poetry he had written from time to time. The daily record of temples visited on his travels throughout the country was almost completely intact, with very little damage. Owing to this, the life of Mokujiki, which had been entirely obscure until just a few days earlier, now took its place in history based on irrefutable documentation. The wheels of history had taken an entirely unexpected turn. The situation had suddenly changed, and nearly all of Mokujiki's daily activities took on a concrete shape.

IV

It never occurred to me then that this research would expand as it did. Neither had I thought it would grow so quickly. At first I had simply thought of Mokujiki as a priest from the Koshu domain (present-day Yamanashi prefecture) whose only works were to be found in Marubatake. Even if there were statues elsewhere, I had little hope of finding them. Yet the reality far

surpassed my expectations. Here I would now like to say a word about how I came to discover his statues throughout the rest of the country.

From the fact that in his papers we find such words as 'Made a statue as a fervent offering and installed it in a providential location', as well as, on the back of a statue, 'One of a thousand', we can surmise that his works were not only numerous but that they were spread over a large territory. Yet there are few mentions of what was created and where. Sometimes there is a note saying 'Yakushi offering' or simply 'offering', but in spite of his great output there is almost no commentary at all. Undeterred, I decided that the sites of his creations could be determined in the following way.

Looking at the two volumes listing the names of inns where he stayed, I found a meticulous record of dates, locations, and names of places where he had lodged. There were some instances where dates had been skipped, or cases where only the dates of arrival and departure were given. Sometimes only the date of his leaving was recorded. I decided that periods for which no dates were given must refer to longer

intervals, and that there must surely be extant Mokujiki statues there. With this in mind I selected the most likely sites and made plans for visiting them. This was my thinking when I went to Sado Island, desolate Kariyado in Shizuoka prefecture, and the villages of Miyazaki and Yamaguchi prefectures. My investigations frequently ran into difficulties, mostly because the places I visited were in remote parts of the country. For the most part, local inhabitants had no recollection at all of a person named Mokujiki. Rarely were any of his works receiving special treatment. Search as I might, there was nothing to be found, and in the depths of Sado I clearly recall feeling completely at a loss. In Shikoku I spent a week covering nine different places, but was rewarded with only two statues found at one spot. Still, all of my investigations were recompensed in some way. Wherever I went, there was something to be found. Thus my morale didn't suffer as I followed his footsteps to the east and west in the hope of discovering something. Whenever I did make a find, it invariably had to be rescued from layers of dust.

I began to fully appreciate the value of

187

firsthand documentation, even if it was only a few handwritten characters. If Mokujiki's list of inns had not survived, most of his works would have undoubtedly been lost to time, eventually falling into decay. No one could have imagined that his statues would be distributed over such a wide area. Finding his works in the most desolate parts of the country would ordinarily be a feat of unlikely proportions. Most of them would have been relegated to sheds and other storage areas as things hardly worthy of notice, unprotected by temple priests and left to the ministrations of termites. In another ten or fifty years their number would surely have been considerably depleted. I and my colleagues had been introduced to Mokujiki at just the right time. The documents we uncovered were slowly but surely unravelling the mystery surrounding Mokujiki.

At Sado and in Miyazaki prefecture, where temples had put him up for extensive periods, we might expect him to have left examples of his work, but according to our investigations to date, he left something behind even at temples where he stayed only three days. This gives an indication of how numerous were the sites we had to

visit. Needless to say, investigative research of this nature requires an enormous amount of time, energy, and funding. The dates in the list of temples he had visited and places where he stayed began in 1773 and ended in 1800, spanning some twenty-eight years. This is the time span of his wanderings throughout the country: from Kumaishi, Matsumae, and Hokkaido in the north, throughout all of Honshu in central Japan, and covering Shikoku and Kyushu in the south. His peregrinations reached all corners of the country, and everywhere he went he left his creations, to one extent or another. Eventually I came to realize the enormity of my undertaking. I also came to realize that it was beyond the power of any individual working alone.

To make the basic material more useful I decided to organize the manuscripts in a more orderly fashion. My aim was to clarify the connection between the places where he lodged and the number of days spent there by creating a daily chronology from the time he began his wanderings to their end, including the ten years after their conclusion. The work of tracking Mokujiki's movements was complicated by the

fact that he preferred to put up at remote hamlets and villages rather than in towns or cities. I spent a great deal of time trying to locate these obscure sites on a map. There were many names that were only known to local residents. Sometimes hours were spent in a fruitless effort to verify just one name. (I sought out maps on a scale of 1:200,000 for the whole country, and then, when that wasn't enough, turned to maps on a scale of 1:50,000.) Still, since the names in his list of places where he had stopped were mostly written in syllabic hiragana and katakana, it was often difficult to determine how they were written in Chinese characters. Moreover, there were cases where the handwriting was difficult to decipher, where the usage of katakana and hiragana was in error, where the local pronunciation was different, or where the names of counties and towns had changed in the meantime. All this was a source of endless headaches. (I would like to note here that I was often helped by Togo Yoshida's painstaking *Dai-Nihon chimei jisho* [Dictionary of Place Names in Great Japan].) In any event, by putting things in order I was finally able to trace on a

map the extraordinary movements of Mokujiki throughout his travels.

V

Since last summer I have spent nearly all of my time travelling, very little at home. When I am at home, I devote my time to putting the investigation results in order and have little time for anything else. Frequently I even do some writing while on the train. The humble outcome of this work was a series of articles under the title *Kenkyu* (Research) that was published on seven occasions in the magazine *Josei* (Woman) from last September to this March. These monthly articles, in which I tried to summarize my progress, together with my monthly investigative work, didn't allow me a moment's rest. The pressure of constant deadlines was always in my mind. Fortunately, I was able to overcome all these difficulties. For one thing, I was blessed with good health. Some unseen force was always at my side. Without this force, it is doubtful that I could have accomplished much at all. It was not so much that I had discovered Mokujiki but that

he had revealed himself to me. I simply continued working as directed by Mokujiki.

My travels last year began in Yamanashi prefecture and then moved on to Sado Island and Tochigi prefecture, followed by Aichi and Shizuoka prefectures, and then deep into Niigata. This year I have visited Oita and Miyazaki prefectures, and then, after returning home once, Shikoku and Nagano prefectures. Just recently I visited Yamaguchi prefecture (the former Suo and Nagato domains) and then Shimane prefecture. Ten days ago I was in Kyoto and Hyogo prefectures (formerly Tanba). As a result of these various trips, I was able to see and examine 350 statues and collect 500 *waka* poems, in addition to taking some 600 photos.

I might mention parenthetically that the travels I mapped were only a fraction of the whole, and the more than 1,000 statues I discovered were only about one-fourth of his total output. How much my relentless efforts had achieved in revealing the whole of his work, how deeply they had delved, it was hard to tell. If anything worthwhile was achieved, it was largely due to the kind and eager help of colleagues and friends. In

particular, the formation of a research group was instrumental in completing the research. At present all economic and clerical aspects of the research are accomplished owing to the hard work of its members. The research group has especially grown active in Yamanashi prefecture, Mokujiki's birthplace. My particular thanks go out to Seizo Komiyama, Kinzo Wakao, Eijiro Amemiya, Mr Nonogaki, Takashi Yamamoto, Shiko Muramatsu, Mr Ishibe, Mr Koizumi, Tamejiro Nakajima, Jiro Noguchi, and Zenkai Omori, among others.

Yet it is not only those in Yamanashi to whom I owe thanks. I would like to note the names of Shotaro Yoshida, Kaichi Katsuta, Taichi Kuwayama, and Kichinosuke Hiroi in Niigata as being of enormous help. Mokujiki's work for the two years around 1803 (Kyowa 3), for which there was not a single piece of documentary evidence, was almost completely clarified thanks in large part to their efforts.

In Sado, recent research has reached a new level of detail. This is largely owing to the tireless efforts of Hoshu Wakabayashi, Jakushi Nakagawa, and Kanto Kawakami, among many

others. Just in this last half-year, thirty statues have been uncovered as well as over sixty hanging scrolls.

I am particularly indebted to Kametaro Ito, who consigned to my hands all the historical documents in his possession concerning Mokujiki, and the many other clergy who provided generous help. I would also like to note how encouraging and helpful were the many communications I received from kind strangers.

In conclusion, I should mention how valuable the publication of a journal on this research has been in making Mokujiki known to a wider audience. In this regard, as well as other matters concerning publication, I am deeply indebted to Ryuzaburo Shikiba for his understanding and earnest endeavours in overseeing this work.

Thus a person who had been forgotten by time is now making his mark on history. Recalling how things stood just yesterday, thinking about how they are today, I can't but marvel at the mysterious workings of fate and be moved to the core of my being. Already three times in Tokyo, as well as in Kyoto and Yamanashi, exhibitions of Mokujiki's work have been held,

attracting thousands of people and leaving an indelible impression on their minds. Even now, throughout the world, words of acclamation and admiration have arisen from both near and far. All who have eyes to see have been astonished. However, those of us engaged in this endeavour have the duty to renew our efforts and see that Mokujiki continues to live on into the future. Here I will end this short essay about the discovery of Mokujiki with thanks to the buddhas for the joy it has given me and for the wonderful creations that Mokujiki left to the world.

WOODBLOCK PRINTS
1939

Woodblock prints fall in the category of handicrafts. That, in any event, is my opinion. The more a print partakes of the essence of handicrafts, the greater its beauty. Yet this truth is often overlooked.

Since woodblock prints are a kind of pictorial art, it is easy to think of them as one of the fine arts. In general, the arts and handicrafts are thought of as opposing concepts, with the result that the more painterly a woodblock print is, the more it is esteemed as art. But, in fact, is that the way it should be? Is it possible to gain a true understanding of woodblock prints by regarding them as art? I believe, conversely, that it is only by viewing woodblock printing as a handicraft that their true meaning can be grasped.

The roots of woodblock printing lie in utility. Woodblocks were first carved as an expedient way of distributing talismans, illustrations in

books, and so forth. In olden days there was also a strong religious demand. Some of the favourite themes were icons of bodhisattvas and stories from the Bible. Since these themes were meant to reach a wide audience, the medium employed needed to be amenable to replication, the chief characteristic of woodblock printing. Mass production is, in fact, one of the most outstanding features of handicrafts.

In the case of fine art, mass production is not a factor for consideration. Fine art does not demand utility or replication. Art that is produced for its own sake, as a one-of-a-kind object, is considered more valuable. Woodblock prints did not take this as their point of origin. In essence, prints belong to the world of craft, not of art. In this sense, art is an individual endeavour while woodblock prints are communal. Woodblock prints seek a wide audience; they do not shun the common people.

However, it is not numbers alone that determine whether something is a handicraft or not. Like the other handicrafts, woodblock printing is an indirect means of expression. It does not create designs directly on paper or cloth with a brush

as painting does. Rather, a rough sketch is made, carved on a woodblock (or a metal plate), and then printed. The carving is indirect, and the printing is even more indirect. Whether in the material used or in the technique employed, there are inherent restrictions, which is the essence of handicraft. Pure art, on the other hand, seeks freedom of expression and abhors restriction; that can be said to be its defining characteristic. Woodblock printing is not absolute freedom of expression; it is a handicraft created under certain constraints. Pure painting is a direct expression of individuality, while handicraft is an indirect expression. It might even be called anti-individualistic. In this sense, woodblock printing can be said to supersede individualism.

There are many kinds of printmaking. Starting with woodblock prints (*mokuhan*), there are *kappazuri* (stencils), *sekiban* (lithography), *doban* (copperplate prints), *fushokuban* (etchings), and more. Of these categories, the most typical and preeminent is the woodblock print. No other technique matches its beauty. The reason lies in the fact that woodblock printing suppresses to the greatest extent the expression of individuality. Or

it might be said that the carving of a woodblock encompasses the greatest restriction on freedom. Printmakers come under extraordinary natural constraints on their work. Strangely enough, however, it is this restriction that is the fount of beauty. Constraint and restriction themselves become a blessing.

It is by understanding these factors that we are able to come to a true understanding of woodblock prints, whether it be in terms of their artistic significance or their social function.

It seems to me that many printmakers are suffering under a delusion. Looking at current trends, it appears that recent prints are simply copying fine art and painting. Some printmakers are working in the *nanga* style of painting. Others are attempting to reproduce the effects of oil. Some cleverly contrived prints are often difficult to distinguish from paintings done with a brush. The question arises: Why are these printmakers working in the medium of woodblock printing at all?

It is not easy in a print to duplicate the expressive depiction that is characteristic of painting. There is a certain sense of pride involved in

overcoming this technical difficulty. Making the seemingly impossible possible, this challenge is apparently irresistible. It can only be accomplished by those who possess considerable skill. However, this is a matter of technique, not a matter of beauty. For prints to follow in the footsteps of painting has very little meaning. The art of the brush and palette should be left to the brush and palette. Even if you succeed in making a plausible facsimile, it is only a facsimile. Woodblock prints must adhere to the way of handicrafts. They must not stray into the pathways of art.

A woodblock print requires the creation of a preliminary sketch, based on which the engraving is done. Many people therefore think of the sketch as artwork and the woodblock as the means by which it is realized. But this would mean that prints are mere thralls to painting. Woodblock printing should not tag along meekly after painting; it should create its own form of beauty. Art should not be created via woodblock printing; woodblock printing should create its own art. Looking at recent work in this field, the woodblock is often nothing more than a medium for creating paintings. Why doesn't pictorial

beauty emerge on its own from woodblock printing; why is the woodblock only a transit station; why is it not the point of origin?

The woodblock print should have its own originality. It should stand alone, on its own two feet. Prints that rely on painting for their meaning are not true prints at all. In order to restore printmaking to its rightful status, it must be freed of its painterly shackles. I implore printmakers: Disengage printmaking from painting. Make printmaking printmaking once again. Paintings made with a brush and prints made with a woodblock must not be confused. Prints must stand on their own; they must not be the slave of painting. Prints that surpass paintings in beauty are genuine prints. It is the duty of printmakers to divest prints of all elements that are inherent to painting proper. What can't be expressed in painting is the realm of woodblock prints. The most beautiful prints are those that are essentially prints, not paintings. Printmaking is a handicraft, not a fine art.

As I said earlier, printmaking comes under many restrictions in terms of material and technique. It might be said, in fact, to be founded on

this lack of freedom. It is different from painting, which takes freedom as its hallmark. Many people see a lack of freedom as the death knell of art. That may be true in the case of the fine arts, but in the handicrafts, lack of freedom is the fountainhead of beauty. This becomes clear if we take *kasuri* as an example.

I consider *kasuri* to be among the most superlative of Japanese textiles. In the process of its production, however, a blurry effect around the edges of the patterns is invariably created due to misalignment. Yet this blurry effect cannot be cavalierly dismissed. While the word 'misalignment' may imply that something is wrong, unneeded and unwanted, without it and the resultant blurry effect, where would the beauty be? The essence, the very reason for *kasuri*'s existence, would be gone. Carried to excess, such misalignment would wreak havoc on the intended patterns, but a certain amount of misalignment and blurriness is what brings out the beauty of *kasuri*, what constitutes its essence, what makes it what it is. In *kasuri* we see a case in which a lack of freedom is the wellspring of beauty.

This issue of freedom, or lack thereof, can be clearly seen in the carpets of China, Persia, and medieval Europe. Owing to the relationship between material and weaving technique, the outline of patterns can't be clearly produced – what should be curved lines often become straight. However, it is precisely this inconvenient but indispensable factor that produces the beauty of carpets. If such patterns were freely created like a painting, the results would be truly trivial. The patterns on the best carpets are not created by a painter's hand; they are not allowed that freedom. Rather than being a product of human whim, carpet patterns are the result of the constraints of material and weaving technique. A pattern does not come first, followed by the carpet; the carpet comes first, followed by the pattern. It is precisely these inconvenient constraints of material and technique that have proved to be the begetter of beauty. This is the essential nature of a handicraft. Humans are not the controlling force; it is nature that plays that part.

Incidentally, not too long ago a certain carpet dealer commissioned some famous painters

to create preliminary sketches; based on these, he had carpets made that were as faithful to the original sketches as possible. A big exhibition was held, and I went to see it. Never have I laid eyes on such a pitiful sight. Each and every carpet was hardly worth looking at.

In the realm of woodblock prints, ukiyo-e have become world renowned. From the Torii school down to Kuniyoshi (1797–1861), bookstores are overflowing with books devoted to the works of the most famous artists. Surveying these prints, one wonders which are the best. Myself, I can't help thinking that the older works are superior. The earlier prints are far and away the best. There is no comparison.

Why should this be? The reason lies in the fact that the beauty of the earlier works is fairly exuded by the print itself. In later prints, with complicated improvements in the production process, painterly elements come more to the fore. In other words, compared to earlier works, the processes of carving and printing achieve a greater measure of freedom. It reaches the point where it is difficult to tell whether it is a woodblock print. It has reached the point where the

essential nature of the woodblock print has been destroyed. Technically this might be seen as progress, but aesthetically it distances these works from true printmaking and makes them a type of painting. In comparison, the early prints are simple and natural, closer to the real nature of woodblock printing; they could only have been produced by that method. The human mind has adapted itself to the print; the print has not fallen under human sway. In later prints, human manipulation runs rampant, inadvertently disclosing their all too human weakness. Conversely, early works leave everything in the hands of nature and thereby gain the strength of nature. To cite an example, the difference between Kuniyoshi and Torii Kiyomasu (early 18th century) should be abundantly clear. Kiyomasu is far more deeply embedded in the handicraft tradition.

As I said earlier, what is called a lack of freedom is only a lack from the human perspective; from the perspective of nature it is simple necessity. The fact that beauty emerges from the handicrafts is due to nature's refusal to bend to human whim, to nature itself exercising freedom. The most beautiful prints are those in

which nature is at work, in which nature is free to play its role. As long as prints are made by human hands, it is only natural that humans should play a part. This does not mean that humans should bring nature under their control, but rather that the wonderful workings of nature should be highlighted and accentuated. A beautiful print is a sign of humankind's trust in nature.

Turning to books with woodblock illustrations, I particularly like those that were produced in the Kan'ei (1624–44) and Kanbun (1661–73) eras, but I am not very fond of the highly reputed *sagabon* ('*saga* books') by Hon'ami Koetsu (1558–1637). Why? Look at the illustrations in the *Ise Monogatari* (Tale of Ise) as an example. Many of them are in the *yamato-e* style of painting; they don't display any of the genuine qualities of the woodblock print. Even the famous *Sanju-roku kasen* (Thirty-six Immortals of Poetry) by Koetsu is not all that good; it simply reproduces the artist's paintings in woodblock form. The true beauty of the woodblock print is sorely lacking. The calligraphy is particularly poor. On the other hand, the *Ogi no soshi* (Book of Fans),

which is generally not that highly regarded, has the best illustrations of all the *sagabon*. People are too easily led astray by Koetsu's name and assume a rather uncritical attitude.

Among the best woodblock prints are many that seem not to have adhered strictly to the preliminary sketch. The sketch simply indicated a general direction, and in many cases was not used at all. Or it was even improved upon in the process of carving and brought vividly to life; the woodblock qualities of the print were accentuated and highlighted. A print is most beautiful when it is truly a print. The sooner the notion that prints are subsumed by painting – or that they are a minor version of painting – is dispelled, the better. This mistaken view of prints is the result of a certain narrowmindedness in modern printmakers, something for which they must bear ultimate responsibility. True woodblock prints are deserving of much more respect and deeper esteem.

Having excised painting from the notion of printmaking, I would like to replace the word 'print' with the word 'pattern'. After all, handicrafts were once synonymous with patternization.

Beautiful prints were invariably accompanied by beautiful patterns. It might even be said that prints that have not become patterns are not genuine prints.

Let me take this point a step further. When painting of any sort reaches its culmination, it invariably enters, of its own accord, the realm of patternization. In other words, it becomes more handicraft-like. This is true, I think, of all the greatest paintings and sculptures the world has to offer. It all becomes pattern in the end. This is as true of the sculpture of the Chinese Six Dynasties (222–589) as it is of the Korean murals from the 4th to early 7th century of the Goguryeo kingdom. Their beauty can be fully understood only from a handicraft perspective.

Patternization is frequently viewed as something rather shallow, as something ranking below painting. Yet when the beauty of painting is reduced to its essence, it is seen necessarily to be pattern. Painting that has not reached this level has not yet achieved its full potential. The early original paintings of the Torii school are so beautiful because they have become fully patternized. They might even be called handicraft

paintings. The illuminated books of medieval Europe possess a similar beauty. When painting is elevated to this level, it takes on a handicraft-like patternization. It is this that is its ultimate goal.

OTSU-E
1960

The Characteristics of *Otsu-e*

Painting can be broadly divided into two categories. One category, as is generally known, consists of paintings that have been created and signed by famous artists and made for viewing pleasure, most of which have only one copy in existence. This is the type of painting to which modern art historians devote their attention. The other category is what might be called folk painting. Quite different in nature from the first category, it consists of unsigned, anonymous works that have some utilitarian value, are produced in mass quantities, and are inexpensive. This type of work is closely tied to the lives of the general populace, hence the reason I refer to it as folk painting. The subject I will undertake here, *otsu-e*, is one of many types of Japanese folk painting: in fact, it is one of the most superlative.

215

The foremost characteristic of *otsu-e* is its anonymity. On this point *otsu-e* is quite different from the similarly popular ukiyo-e, which consists almost entirely of signed works. However, with the recent penchant for attributing particular works to particular artists, there are those who attribute *otsu-e* paintings to some artist or other.

The first practitioner of *otsu-e* has been variously attributed to Matabei, Domo no Matabei, or Iwasa Matabei, and in later generations there were even individuals who claimed to be the descendants of one or the other. These names have their roots in Chikamatsu Monzaemon's 1705 play *Keisei hangonko* (The Courtesan and the Hangon Incense), in which there appears an *otsu-e* artist named Domo no Matabei. In the public mind this character was quickly assumed to be Ukiyo Matabei and then Iwasa Matabei, eventually giving rise to the widely held belief that Iwasa Matabei (1578–1650) was the father of *otsu-e*. There is no historical evidence to support this attribution, however. It is simply a popular legend.

Another possibility concerning the origin

of *otsu-e* is that, owing to political unrest, paint-ers were having a hard time making ends meet, and took up *otsu-e* to eke out a living. This hypothesis, proposed by modern historians with a dislike for anonymity in art, has no factual support. It is much more reasonable to think that *otsu-e*, like all folk painting, arose naturally from a particular unattributable confluence of events. Particularly in the Orient, with its under-playing of the individual and its superabundance of anonymous paintings, it is much more logical to think of *otsu-e* as one example of this phe-nomenon. In fact, there is not a single example of older *otsu-e* that bears a signature. In much later works there are some with the name 'Gonji'; these, however, are not genuine *otsu-e* but merely paintings done in the *otsu-e* manner. In brief, *otsu-e* were non-individual in origin, bearing neither signature nor seal.

Moreover, it is clear from documentary evi-dence that the work of creating an *otsu-e* was largely a family affair. In most cases the father did the outlines, the wife the colouring, and the children the areas requiring dotting. Conse-quently, it is difficult to call these *otsu-e* the

work of an individual; in the majority of cases they should more properly be called communal work.

To summarize: while the foremost feature of *otsu-e* is their anonymity, second is the fact that they have some sort of utilitarian value, that they were not made for artistic appreciation alone. At the very beginning *otsu-e* were a type of Buddhist painting, answering the religious needs of the common people. They were kept in the family Buddhist altar and displayed on walls during religious ceremonies, and fulfilled other religious functions. Thus *otsu-e* were not artworks in the strictest sense, but religious paintings. The same situation pertained in the West, where unsigned sacred images were produced in large numbers at a low price. In their second stage of development *otsu-e* moved thematically from the religious to the secular, but in either case travellers regarded them primarily as a kind of souvenir.

The third feature of *otsu-e* is the fact that they were produced in large numbers, numbers which were made possible by a strong popular demand that called for the repeated depiction of the most favoured themes. This strong

demand also made this type of painting a viable vocation. The fourth characteristic evident in *otsu-e* is that massive repetition led to simplification, to abbreviation, and gradually to fixed themes and a strong distinctive style. This, in turn, made it possible to produce even greater numbers at an even faster pace. In this way, *otsu-e* eventually achieved the status of a traditional folk painting.

The last feature is price. *Otsu-e* were sold inexpensively, enabling travellers to purchase them as mementos with their pocket money. This was undoubtedly true of all paintings produced by artisans working prolifically in anonymity. Their work was welcomed by the common classes because it was cheap.

Thus *otsu-e* were created by anonymous craftspeople, produced in large numbers in response to popular demand, adhered to a distinctive simplified style, and were sold cheaply. Moreover, since *otsu-e* were not the work of famous painters but folk art created by unknown artisans, they have been given short shrift by standard histories of art. On the other hand, they played an important role in the lives of the

common people on a utilitarian level, and their natural freedom of expression and lively brush-work proved irresistibly endearing. Technically, speed and volume led to complete mastery of the craft, to the point where artisans became virtually unconscious of their own movements, a freedom afforded by the nature of the craft. If freedom is the hallmark of beauty, then *otsu-e* deserve much higher marks than they have here-tofore received. The reason that folk painting has been neglected up to now lies in the over-weening bias toward art by individual artists. Conversely, this was precisely why *otsu-e* were supported by the general populace, since they were produced repeatedly in mass numbers and sold at affordable prices.

The Etymology of *Otsu-e*

Otsu-e's first documented appearance in history occurs in a haiku written by Basho in 1691:

> *The first* otsu-e
> *of the new year,*
> *what Buddha will it depict?*

As a place name Otsu obviously refers to the town along the shores of Lake Biwa in present-day Shiga prefecture, but rather than thinking of *otsu-e* as first appearing in that town, it might be more reasonable to think of it as coming from the general feudal area of which the town of Otsu was a part. From Basho's haiku we can assume that the word *otsu-e* entered the common parlance sometime around the Genroku era (1688–1704). However, from the fact that a book titled *Oiwake-e* was published in 1709, we can see that the term *oiwake-e* also has a long history. From surviving picture books we also see that Oiwake is often depicted as having shops where *otsu-e* were sold. Topographically, Oiwake can be seen as central to the town of Otsu. The place names Yotsunomiya and Otani also appear at a later date, and geographically are not distant from Oiwake. However, documentary evidence indicates that *otsu-e* and *oiwake-e* were the two principal designations for this genre of painting; of the two, *otsu-e* eventually became the more commonly used, in part due to Basho's haiku and in part due to the fact that Oiwake was located within the larger Otsu area. For such reasons as this, *otsu-e* inevitably became

the name most familiar and widely used among the general populace.

The Era of *Otsu-e*

Given the fact that *otsu-e* are unsigned, it is difficult to assign specific dates for individual works, but surveying detailed documentation, it is possible to ascertain the genre's approximate date of origin. The oldest date that can be determined with accuracy occurs in the Kanbun era (1661–73), but it would not be unreasonable, I think, to assign the beginnings of *otsu-e* to a somewhat earlier date, to around the first year of the Kan'ei era (1624–44). The period from the Kanbun era to the Genroku era (1688–1704) saw a great flourishing of Buddhist images, but around 1682 secular paintings also began to appear, and by the end of the 17th century religious and secular paintings had achieved an even balance. Contemporary culture had reached unprecedented heights, and from the Genroku to the Kyoho era (1716–36) secular paintings were produced in ever greater numbers, with many superlative works among them. By 1709, the first year of

the Hoei era, there had been a huge increase in thematic material, as shown by documentary evidence. The time span from around 1736 to 1800 can be considered the middle era of *otsu-e*, but from about 1820 a decline gradually set in. *Otsu-e* managed to survive by the skin of its teeth from approximately 1865 to 1870, a time which witnessed the transition from the feudal Tokugawa era to the modern Meiji period, but thereafter fell into desuetude, lowering the curtain on more than 200 years of history.

Origin and Transition of *Otsu-e* Themes

As mentioned above, *otsu-e* painting began to appear sometime around 1624. As we can see from surviving examples, it consisted mostly of Buddhist images, of which there were plainly two types. One type consisted purely of Buddhist icons of Amida Buddha, the bodhisattva Jizo, the deity Fudo Myoo, and others. The other type consisted of deities emerging from the syncretism of Buddhism and the native Shinto religion, such as Uho Doji (Child of Plentiful Rain), Shogun Jizo (Victorious Jizo), and Hachiman-shin

(God of Hachiman). In later years the gods of folk religions were added to this mix, resulting, one could say, in a third type, including Daikoku-ten (God of Wealth), Shoki (Demon Queller), and Geho (God of Longevity).

The Buddhist images generally followed older conventions, with the earlier works in particular adhering closely to established practice. However, in keeping with the general nature of folk painting, the style was gradually simplified, going so far as to press patterns on selected areas of the paper with engraved pieces of wood. In the genesis of any phenomenon there are historical precedents; in the case of *otsu-e*, its roots can be found in the Buddhist prints that were widespread in the Muromachi period (ca. 1336–1573) and thereafter. Comparing surviving works, the similarity in composition is pellucidly clear. Buddhist prints had made the transition to hand-drawn paintings.

At first glance, in order to meet the demands of speed, affordability, and volume, it might seem that woodblock printing would have the advantage, and that hand-drawn work would be a step backward rather than forward. However,

this was not the case. First of all, in woodblock printing the proper woodblock would have to be procured and an engraver employed, neither of which could be done cheaply. Moreover, the colour had to be added by hand, a time-consuming operation in itself. In the end, it was undoubtedly much cheaper to use the freedom afforded by the human hand. With practice the work would become faster, and complicated designs would be simplified by the natural movement of the brush, making the work not only faster but easier. This is the process by which the early *otsu-e* transformed the conventional Buddhist print into a much simplified, hand-drawn folk painting. Interestingly, some of the more intricate parts of the drawing (such as faces or depictions of birds) were occasionally created with pieces of engraved wood, thus speeding up the process. Colour was added by stencil, another timesaver.

In the early *otsu-e* of Buddhist images, the mounting of the picture was invariably hand drawn. Since separate cloth mounting would add to the cost, hand-drawn mounting was undoubtedly employed to keep the price within

the economic range of the general populace. Concerning the size of the paper, while the large *oban* size (58 × 32 cm) is sometimes encountered, the vast majority of *otsu-e* were depicted on two *hanshi* sheets (24~26 × 32~35 cm) pasted together. The rare *oban* prints were probably from the earliest, most primitive stage and eventually devolved into the *hanshi* size. In the middle stage of development, *otsu-e* again evolved into a single-sheet size. Compared to the earliest stage, the variety of Buddhist themes dealt with and the size of production both grew proportionally larger, and by the Genroku era (1688–1704), as mentioned earlier, religious and secular themes reached a balance. Thereafter, however, Buddhist images continued to decline both in variety and in numbers produced, and by around 1815 they had completely disappeared.

Thus, while it is true that Buddhist images preceded secular images in the evolution of *otsu-e*, the period of transition from one to the other is not all that clear. As early as 1682 Ihara Saikaku's *Koshoku ichidai otoko* (The Life of an Amorous Man) mentions that folk paintings with a variety of secular themes were being produced in the

Otsu-Oiwake area. Consequently, the time around 1680 can be regarded as a transitional period. As mentioned above, the time span from the end of the 17th century to the middle of the 18th saw a sudden rise in secular themes, a phenomenon that was most certainly influenced by the popularity of ukiyo-e and the publication of illustrated books called *e-hon* ('picture books'), which further added to the thematic variety of *otsu-e*. As a result, it seems perfectly reasonable to assume that just as Buddhist themes had their roots in religious woodblock prints, secular themes had their genesis in ukiyo-e.

In fact, in some *otsu-e* believed to have been painted around the Genroku era (especially depictions of handsome men [*yaro*] and highly placed courtesans [*tayu*]), there is little difference between *otsu-e* and ukiyo-e. There are even some cases where it is possible to date an *otsu-e* from its similarities to ukiyo-e. However, there is one significant difference between the two: whereas ukiyo-e is produced by woodblock printing and bears, for the most part, the name of the artist, *otsu-e* is always hand drawn (with the exceptions mentioned above), anonymous, and stylistically

very simple, resulting in a considerable difference in price.

One more difference that comes to mind is the fact that many of the early secular *otsu-e* had a satirical aspect. At a time when freedom of speech was tightly controlled, this afforded one of the few venues for expressing criticism, accounting for the large number of works ridiculing contemporary society, as can be seen in the depictions of spear-bearers (*yarimochi yakko*), ogres reciting religious chants (*oni no nenbutsu*), and the lantern and the bell theme (*chochin tsurigane*). One feature of these early secular pictures/paintings is that they fit perfectly onto two sheets of paper pasted together, precluding the need for a painted mounting, which completely disappeared. Compared to Buddhist images, they also became much more colourful, with a concurrent increase in the number of themes. A variety of colours was used, such as ochre (*odo*), dyestalk red (*bengara*), vermilion (*shu*), whitish green (*byakuroku*), bluish black (*guzumi*), and chalk white (*gofun*), but as a rule these colours were never mixed. It was the general practice to give the cut paper an initial

coating of yellow. Over this coating the picture was coloured in, to be followed by lines drawn in black as needed. Gold dust was frequently applied to Buddhist images, but apparently owing to cost this was, in fact, mostly brass dust.

In regard to the development of thematic material in *otsu-e*, the first Buddhist themes were a response to the religious demands of the commoner classes; secular themes were stimulated by the cultural currents of the times (e.g., depictions of actors and courtesans); and later there was the advent of the religious movement called Shingaku (a combination of Neo-Confucianism, Zen, and Shinto), which had a transformational influence on *otsu-e*. In terms of content, this ushered in the third stage of development. Buddhist images showed signs of decline, and secular themes showed further increase, taking on special meaning. Earlier *otsu-e* had a satirical aspect, but under the influence of Shingaku they also became educational.

One of *otsu-e*'s most outstanding features during this period was the shift from the use of two sheets of paper to the popular use of one. In addition, the area around the illustration came

to be inscribed with educational *waka* poetry, a characteristic of the third period. The *waka* were written in a mixture of difficult Chinese characters and the more easily readable hiragana, another feature of this stage. Earlier *otsu-e* also had inscriptions of this sort, but they were written entirely in Chinese characters (and, in fact, were a form of classical Chinese), added to the finished work by literati. Poetry written with a liberal use of hiragana was a feature of the middle period, when *otsu-e* were drawn on single sheets of paper rather than on two sheets pasted together.

Here I would like to say a bit more about Shingaku. Shingaku was a religious movement founded by Ishida Baigan (1685–1744) and Teshima Toan (1718–86) and is commonly known as Sekimon Shingaku. It had considerable influence on the spiritual life of the times. The dissemination of *otsu-e* paintings undoubtedly played a role in its spread, leading to a further strengthening of *otsu-e*'s educational side. In any event, the melding of painting and poetry, as well as the medium of a single sheet of paper, is one of the outstanding features of the middle stage of

otsu-e development, creating an even tighter bond between this genre of painting and the common people.

Perhaps due to the fact, as already mentioned, that the size of the paintings became smaller in the middle stage, the style underwent greater simplification and the brushwork became rougher. This is characteristic of the *otsu-e* of this period. In a certain sense the brushwork also became freer, and *otsu-e* began to assume the aura of genuine folk painting. The underlying reason for this phenomenon is that the paintings had become less expensive owing to the use of smaller *hanshi*-sized paper, which allowed purchasers to buy more than one at a time. In fact, there are cases in which a number of *otsu-e* have been combined to form a scroll, a format which is not found outside of the middle period with its *hanshi*-sized paper. The publication in 1780 of the book *Otsu miyage* (Otsu Souvenirs) is a good example of the road that *otsu-e* had taken. The book contained thirty-six thematic illustrations. Still older is the 1709 publication *Oiwake-e*, which is actually a collection of haiku with *otsu-e*. It contains forty-two types of themes, so that

we can see that the number of themes was fairly large even at this date. Naturally, the most favoured themes gradually pushed out the less popular, and from the middle to the late period the number eventually shrank to ten, a trend I find interesting in itself.

The ten themes were *Geho hashigo sori* (the God of Wealth on a ladder shaving the head of the God of Longevity), *kaminari to taiko* (God of Thunder and drum), *takajo* (hawker), *fujimusume* (wisteria maiden), *zato* (Zato the blind masseur), *oni no nenbutsu* (ogre reciting a religious chant), *hyotan namazu* (catching a catfish in a gourd), *yarimochi yakko* (spear-bearer), *tsurigane Benkei* (Benkei carrying a bell), and *Ya-no-ne Goro* (Goro with arrowheads). Since these themes had an educational facet, they also functioned as talismans. Furthermore, *otsu-e* took on a strong comical cast, fell in quality, became further reduced in size, and in the end diverged from the *otsu-e* of old, entering into a period of final decline. In the time around the middle of the 19th century, from the demise of the feudal regime into the beginning of the modern Meiji period, *otsu-e* finally disappeared from the pages of

history. It is interesting to note, however, that around the time the ten themes became the standard repertoire, they were set to music, producing a type of folk song called *otsu-e bushi* that outstripped the paintings in popularity.

Thus, in outline, we can see how *otsu-e* began as Buddhist paintings, evolved into secular images, took on a satirical bent, adopted an educational element, and finally declined into talismans. As with other arts and crafts, the older works are the most endowed with artistic nuance. Among the myriad types of Japanese folk paintings, *otsu-e* is undeniably one of the finest Japan has to offer. If someone should ask about Japanese folk painting, they can best be served by being directed to this genre.

In conclusion, I should mention that the number of themes that appeared throughout the history of *otsu-e* amounted to approximately 120. Of these, there were about twenty Buddhist themes, the remainder being secular.

HANDICRAFTS AND SESSHU
1950

I

Not too long ago, at Jufuku-an in Kamakura, I purchased an ink painting – a scroll, in fact – bearing the seal of a priest named Toyo. It depicted a heron sitting on an old willow tree and was hanging in an alcove. I was struck by the painting the instant I saw it. Judging from its general style, I immediately thought it must be from the Muromachi period (ca. 1336–1573). Since I was standing at some distance from the painting, I couldn't see its seal. While I had no idea who the artist was, I was so moved by its beauty that I instantly thought of purchasing it for the Japan Folk Crafts Museum. At the time, Shokin Furuta (1911–2001), who was standing next to me, said that the seal read 'Toyo'. For a second I couldn't recall who Toyo was, not until I was told it was Sesshu, the great master of ink

painting from the Muromachi period. 'Toyo' was Sesshu's religious name. If the seal was genuine, the painting would surely be Sesshu's work, which would not be surprising since the scroll was obviously a masterpiece. The provenance of the scroll was clear: it had formerly belonged to a famous collector in the early Meiji period. Yet it had apparently never been catalogued among the listings of Sesshu's work. Unfortunately, my knowledge of Sesshu was very limited, and I was unable to determine whether the scroll was genuine. I looked forward to an expert's opinion. Later, however, I checked the authoritative *Koga biko* (Notes on Old Paintings) and found a matching seal.

And yet, to me, it was not a matter of crucial importance whether the painting had a seal or not. When I first saw the scroll, I did not notice the seal, nor was it anywhere in my thoughts. This way of looking at artwork may be called simplistic, but the painting itself was superlative, and that was enough. Conversely, to my mind, judging a work from its signature is what can be called simplistic. I didn't want to buy the scroll because it was a Sesshu. I didn't think it was superlative

because of its seal. The value of the painting did not depend on whether it was a work by Sesshu or not. Whether I was told from the beginning that it was his work or was informed of it later on had no effect on the quality of the work. Rather, I thought it rather splendid even for a Sesshu, much superior to the usual Sesshu painting.

I have almost never judged a work of art by first looking at its signature. This way of assessment holds no interest for me. If what I see is good, it is good with or without a seal. The fact that the majority of people examine the seal before anything else seems to me almost ludicrous. Such people shun works without a seal, assign them a lower level of value, and antique shops accordingly lower their prices. On the other hand, if the work does have a seal, the buyer feels safe in his selection, and dealers can proudly point to it as a sign of the work's value. As for myself, I am mostly interested in works without a seal or signature. It may be overstating the matter to declare that a seal is an impediment, but the truth is that works with a seal are created by individuals, and there are not many individual artists possessing great scale or

depth. Moreover, individual artists invariably have certain irritating quirks, making it difficult to live comfortably with their creations on a day-to-day basis. You feel as though they are making an unwarranted claim on your attention. More importantly, works by individual artists are very self-conscious – that, in fact, can be said to be their chief characteristic – and one can't help feeling them rather tiresome. In the end, there seem to be surprisingly few works with a seal that are really good.

In comparison, since unsigned works are not made under the name of an individual artist, they have fewer eccentricities and no particular point to make; rather the general feeling is one of freedom. In addition, unsigned works borrow something from the era in which they were born, giving them a beauty beyond the capacity of the individual. Yet it is not my intention here to claim that everything should be unsigned; nor am I claiming that all unsigned works are exceptionally beautiful. What I am asserting is that people in general place too much faith in seals and signatures. In consequence, it seems, one of the self-assumed tasks of art historians is tracking

down the names of the artists behind anonymous works. One even gets the impression that it has become an obsession. Yet I think it is worth noting that this kind of tenacious attribution is often meaningless. It seems strange to me that people should not recognize the real value of a work just because it happens to be unsigned. The attempt to attribute every laudable artwork to an individual artist has become a disease of modern historians. This obsession, in fact, often makes it impossible to unravel the mysteries of a particular work of art. Rather, by assigning a name to a work, the work itself becomes secondary. Only when there is no seal does its true beauty emerge unobscured. It is important to remember that beauty does not necessarily have its roots in the individual artist.

Not to be repetitious, but it doesn't really matter if there is a seal or not. With or without, beauty is beauty. There is no need to be concerned about seals. However, there is one thing that is important, which is to look directly at the object itself. It won't do to base one's assessment on a seal, or to decide the value of an object based on a signature, or, worst of all, to lose

confidence in one's ability to judge for want of authentication. One's assessment of an object must be free and unhampered, with nothing coming between you and the object. You must look at it directly. To decide that a particular piece must be valuable because it has a particular seal is weak and demeaning. Your assessment only gains meaning when you look at the object directly, free and unfettered.

As I related earlier, when I purchased the scroll with a Toyo seal for the Japan Folk Crafts Museum, I didn't buy it because of the seal. I didn't buy it because the name Sesshu was associated with it, and I didn't consider it beautiful because it was thought to be by Sesshu's hand. Even without the Toyo seal, I would certainly have felt the same sense of joy when buying it. Even without a seal, in my eyes the painting would still be fine as it was. A seal doesn't validate a painting, a painting validates the seal. While it may seem strange, I have never bought an artwork on the basis of its seal. Seals have always been something I left to the last. Most of the works held by the Japan Folk Crafts Museum are without seals, but that is merely a matter of

happenstance: it just chanced that the most beautiful works worth collecting were anonymous. It also followed from the fact that the majority of pieces housed in the museum are handicrafts. Necessarily, the collection is vastly different from those that focus on works authenticated by seals and signatures. Many beautiful works have been overlooked due to this fetish for seals. The realm of beauty stretches out before our eyes, vast and expansive, regardless of the presence or absence of seals. The greatness of the early tea masters lies in the fact that they recognized the value of anonymous works. The weakness of present-day masters is that they are too timorous in the face of anonymity. If only people would broaden their perspective and adopt a less fettered point of view, they would suddenly find themselves in a world of amazing beauty.

In the end, what I am attempting to say is that even if a work has a seal, you should look at it as though it does not. Likewise, if an art piece is without a seal, you should not let that concern you. Whether it is a painting or a pot, you must first look at the thing itself. Here I fear I may be

repeating myself once again, but I did not buy the Sesshu because of the seal.

II

Among my recent activities I count the collecting of old paintings, some of which bear seals and one of which was the Sesshu mentioned above. Certain members of the Japan Folk Craft Association expressed wonderment at the purchase of the Sesshu, asking what connection it could possibly have with folk crafts. They seemed to think there was something dubious about the purchase. I feel obliged to say a few words about this interesting episode.

One reason for purchasing old paintings on the museum's behalf was that its collection in this genre was relatively weak, and I wished to give it greater weight. It also came to my notice that, in comparison to other antiques, old paintings were relatively cheap, and I thought it best to take advantage of this low pricing while I could. Owing to rampant inflation, the prices of ceramics and other antiques had shot up to fifty or a hundred times what they were before the

war. Old paintings were much cheaper, only about twenty times what they once were. Naturally, popular old paintings by Sotatsu (early 17th century) and Korin (1658–1716) were exorbitantly expensive, but in general old paintings were outrageously cheap – especially when compared to more recent paintings, which were on a different level altogether. Another reason for the deflated pricing of old paintings was the fact that they required an educated eye to assess them, since there were many fakes around, making old paintings a risky venture. Distinguishing the good from the bad was difficult, and there were few experts up to the task. In general, these were the reasons that old paintings had such a low market value.

Not being wealthy, I couldn't afford anything with a high market value. Within the museum's extensive collection there are very few high-priced objects. Before the war the most I paid for a single object was a mere ¥900. Other than that one piece, there were only ten pieces or so that cost ¥300 or ¥400. The rest cost less than ¥100, with some valued at five or ten *sen*. Some collectors referred to me as 'the cheap collector',

and they were right. To me, making a purchase of several thousand yen was nothing more than a dream. A price of tens of thousands of yen was unthinkable. There was once an individual who paid several tens of thousands of yen for a tea-ceremony bowl. For that amount of money, I thought, he could easily have bought the museum's entire collection! Nowadays I am recognized as a bona fide collector, but I doubt there are any other collectors who buy so much with so little money. That's because I leave the collecting of already recognized pieces to others; I concentrate on beautiful things that have yet to be recognized. In short, I have always collected things with little market value. The path I have trodden is different from that of ordinary collectors; in a sense, you might even say that I have been one step ahead of the rest. In fact, every time I have started collecting a particular genre, its price has unfailingly risen. This has happened any number of times, and in that way I feel fortunate to have brought to light many previously unrecognized works. This is what has enabled me to carry on with this work. My collection of old paintings is founded on the same principle.

You might wonder how I managed to acquire a painting by Sesshu, one of Japan's most eminent painters. Strangely enough, since his work was not then popular, its market value was quite low, not even coming close to recent artists like Kokei Kobayashi (1883–1957) and Yukihiko Yasuda (1884–1978). This turned out to be a fortuitous event, since it meant that even someone such as myself could obtain a work by a famous artist. As I mentioned earlier, I didn't acquire the Sesshu because of his name; I bought it because I was attracted by the quality of the work. It didn't matter in the least whether the work had a seal or not. It just happened by chance that the painting bore the Toyo seal.

One more motive for my collecting old paintings was that I had grown tired of the standard array of objects assembled by ordinary collectors. There were some excellent pieces among their collections, but they were mostly conglomerations of the good and the bad, without rhyme or reason. I wanted to reflect our way of thinking in this field as we had done in others. Unfortunately, the timing was bad, for even though old paintings were relatively inexpensive, they were

not cheap. For financial reasons there was not much that we could do; still, I thought, we should be able to achieve a modicum of success. In the not-too-distant future I hope to exhibit the fruits of our labour for the general public.

Here I would like to return to the question of the connection between Sesshu and handicrafts. In the past, and perhaps even now, we have been misinterpreted as declaring that there is no beauty other than the beauty of handicrafts. As a matter of fact, I have never once made a declaration of that sort. The reason that people have jumped to this conclusion is most likely the fact that we have strongly insisted on the beauty of hitherto completely ignored craftware, which was construed in turn to mean that we thought nothing other than handicrafts was worth consideration. The fact that we have stated that there is very little beauty in the aristocratic arts and the work of individual artists was taken to mean that we thought only handicrafts possessed beauty, that they represented the apex of beauty. Furthermore, since we took handicrafts as being a yardstick for all beauty, and formed an aesthetic theory around this

notion, we were seen as negating the possibility of any other kind of beauty. As a matter of fact, it was only in the Edo period (1603–1868) that a clear distinction was made between the aristocratic arts and the handicrafts. In China this occurred in the Qing dynasty (1644–1912). Prior to this, the aristocratic arts were simpler in expression, following the same principles that lent handicrafts their beauty. Particularly with unsigned works, to a greater or lesser extent, one can see the workings of this simple principle. Simple beauty, wholesome beauty, utilitarian beauty, everyday beauty – these are the hallmarks of the handicrafts. In our attempt to make handicrafts a standard for beauty, it was presumed that we believed no other beauty existed. It is true, however, that there are few great works among the aristocratic arts in the Edo period and during the Qing dynasty, and when there is one, it is because it follows the principle of simplicity. It is safe to say that the beauty of handicrafts, the beauty of everyday life, represents the essence of beauty. By making this assertion, however, we have been likened to the domineering priest Nichiren (1222–82), who

denied the validity of all interpretations of Buddhism other than his own.

Our stance, in fact, is a more liberal one. For us, beauty is beauty. A particular object is not beautiful because it is a handicraft; neither is it ugly because it is not. Whatever it is, the beautiful is the beautiful. The aristocratic arts are not embraced because they are aristocratic; the non-aristocratic arts are not considered ugly because they are not aristocratic. Whether a particular object is an aristocratic work of art, whether it is a handicraft, or whether it is something in between, what is beautiful is, in short, beautiful. The seeing eye should not be inhibited by invidious distinctions. It should not, as up to now, praise to the skies the aristocratic arts and almost completely ignore the handicrafts. Neither should it refuse to recognize beauty other than that of craftware or fall into a narrow insensitivity to other types of beauty. The perception of beauty should be unfettered; only then can the eye truly see.

Only when this kind of freedom of perception has been gained can the beauty of craftware be properly appreciated. It is precisely this

freedom that has enabled us to revitalize the whole realm of hitherto neglected handicrafts. It is also this freedom that allowed us to call attention to the unwholesome artificiality of the majority of aristocratic arts. This amounted to a complete reversal of values. Some mistakenly believed this reversal was not due to a new, free mode of perception but simply to an instinctive reaction against previous styles. To my mind, however, this reversal would not have been possible without a freer, more liberated way of seeing things. Unsigned pieces began to attract more attention than the signed, there was a greater awareness of the arts of the people vis-à-vis the arts of the aristocratic classes; utility began to be favoured over the merely decorative. All of this could not have been possible without a new-found freedom of perception.

There is absolutely no reason for us to abandon this new freedom of perception. On the other hand, there is no reason for us to fall into the fallacy of thinking that handicrafts are the sole possessors of beauty. Even works by individual artists can be beautiful, as can the aristocratic works of the feudal period. There is no rule

saying that everything created by an individual artist is ugly, or that everything created by ordinary people is beautiful. I am only saying that aristocratic and individual artists have a difficult road to tread, accounting for the fact that truly beautiful works from their hands are rare.

On the surface, it may seem there is nothing linking Sesshu with handicrafts. Still, whenever two things are closely compared, there is invariably some connection. The difference between Sesshu and handicrafts may be likened to the difference between the Zen school of Buddhism (which stresses self-exertion in achieving enlightenment) and the *nenbutsu* schools (which stress reliance on a greater power). These two approaches are different, it is true, but they are like two paths leading up a mountainside; the routes are different, but they converge at the peak. The teachings of Shinran (1173–1262) are not inimical to the teachings of Dogen (1200–53). Their scriptures and doctrines may be different, but what is important is that their ultimate goal is the same. Something similar applies to the aristocratic arts and handicrafts: the seeing eye that perceives the beauty of one should be able to

perceive the beauty of the other. This freedom to appreciate beauty must not be lost. Losing it, the ability to see the beauty in handicrafts would also be lost.

Hearing that I had bought a Sesshu, some people were undoubtedly perplexed. But what would they think if I told them that there has long been a Cézanne hanging on the wall of my home? Is it a contradiction that I should make this use of one of the many individual artists among us? Shouldn't we welcome what is beautiful, whatever that might be? The freedom to choose freely must not be relinquished. But neither should the process of selection be done randomly. There must be an underlying consistency. This consistency is made possible by the capacity to perceive with a free and open mind, the capacity to see beauty as beauty. Among the truly beautiful, whatever they may be, there is invariably an inherent harmony.

Whether it be the handicrafts or the fine arts, we must learn to see freely with both eyes open. It was precisely this want of freedom of perception that led to the long-time failure to recognize the beauty of the folk arts.

253

WASHI
1943

Washi is a very simple material, yet the longer I look at it, the more enthralled I become. Hand-made *washi* (traditional Japanese paper) is replete with appeal. Looking at it, touching it, fills me with an indescribable sense of satisfaction. The more beautiful it is, however, the more difficult it is to put to use. Only a master of calligraphy could possibly add to its beauty; it is exquisite just as it is. This is wonderfully strange, for it is merely a simple material. Yet plain and undecorated as it is, it is alive with nuanced beauty. Good *washi* makes possible our most ambitious creative dreams. Contemplating *washi*, I also contemplate its future.

I wonder, as I am wont to do, about the rationale behind *washi*'s beauty. Ultimately, it resides in the nature of the material itself – not an unreasonable assumption, I think. This basic material is brought to life through manual

manipulation and transformed into high-quality *washi*. What, then, is the fundamental nature of the material? It is a gift from nature; nothing more, nothing less. The more its inherent nature seeps to the surface, the greater the beauty that emerges as a result. Looked at in this way, the mystery of *washi*'s beauty comes to light.

This raises a number of questions: why does handmade paper have a certain warmth; why does the natural colouring of the paper seem so satisfying; why does drying in the sun bring out the paper's best qualities; why does drying on boards add special lustre; why does the cold of winter protect the paper; why do deckle edges often add to the paper's allure? The answers to these questions are patently evident – these factors bring out the blessed warmth of nature. Nature engenders the paper's depth and profundity without falsification. Receiving the full force of nature, all *washi* is beautiful. Looked at in this way, *washi* can be understood.

There is no 'I' in the world of *washi*, hence no reason for personal confrontation. *Washi* is, above all, likeable and friendly. There may be some people who are unmoved by its beauty, but

for those who are drawn to it, a special bond is forged. Showing my most beloved *washi* to others, I have never failed to impress. Seeing it with their own eyes, they invariably recognize its beauty. *Washi* begets love and affection. It strengthens one's feelings of reverence for nature and one's devotion to beauty.

Here we see one of the wonders and joys of Japan. There is no other country in the world that possesses such remarkable paper. It contributes immeasurably to the beauty of Japan, and its existence should never be forgotten.

People often judge the level of a civilization by the amount of paper it uses. That, however, is simply a matter of volume, not quality. Quality is how the heart and soul of a civilization should be measured. How can bad paper and high civilization possibly be bedmates? One can gain a glimpse of the quality of a people's life by the kind of paper they use for writing letters, for literary works, and for various other tasks. Paper should not be deprecated. To do so is to deprecate beauty itself.

We are now deluged by both bad paper on the one hand and good paper on the other. The

choice of which to use is up to the user. But the user and the used are not two things, but one. We are individually called upon to make the right choice.

People these days waste a tremendous amount of paper. They waste it because it is of poor quality and is made to be wasted. Or it might be more correctly said that the perception of good paper as a precious commodity has dwindled. But does this careless treatment of paper mean that our lives are any better? No, it is precisely such irresponsible thinking that should be avoided at all costs. Both from a moral and aesthetic point of view, it should be shunned. It lacks any feeling of gratitude or appreciation for one of the blessings of nature.

How did this unfortunate situation transpire? It is due to the debilitation of *washi* itself. It is due to the rampant spread of Western paper. Properly made, there is no such thing as unsightly *washi*. Yet most people view *washi* as being retrograde, behind the times. Hurried attempts have been made to improve it, but this has resulted in incalculable damage to its true nature. The present pathetic situation is the result of turning our

backs on long-held tradition. It comes from the cavalier abandonment of beauty in the name of the profit motive. Why haven't we learned from history and innovated for the future? There is no safer foundation than history. Building on history, Japan would be unrivalled in the world of paper.

When I say that all *washi* is beautiful without exception, you may think that I have gone beyond the pale. Let me reply without the slightest hesitation: look for yourself among older *washi* and see if you can find one example that is poorly made. It is an impossible undertaking. They have all been made by set procedures that guarantee their quality. This also applies to recent *washi* that relies on traditional methods. Not one is feeble or weak; not one is allowed to deviate in the slightest from its true nature. There are no defects in *washi* made according to historical principles. The only question is which is the most beautiful.

The three principal sources of *washi* are the *ganpi* (*Wikstroemia sikokiana*), *kozo* (*Broussonetia kazinoki*), and *mitsumata* (*Edgeworthia chrysantha*) trees. It is the fibre of these three that produces

the myriad types of *washi*. In this triad, *ganpi* occupies the central position; *kozo* is on the right, and *mitsumata* on the left. In terms of refinement, lustre, and dignity, *ganpi* is incomparable and lasts the longest. It combines pliability and strength, romance and reality. It is impossible for any other paper to achieve this level of refinement and elegance. *Kozo*, on the other hand, might be likened to a warrior guarding the kingdom of paper. Its fibres are thick and strong; it can handle any job, no matter how tough. It is because of these qualities that *washi* is still viable today. Without *kozo* the world of *washi* would grow weak and enervated. In contrast, *mitsumata* is soft and feminine. It is impossible for any other paper to be as graceful and poised. It is finely grained and smooth textured, genial in character. Without *mitsumata*, *washi* would lose much of its charm.

Ganpi, *kozo*, and *mitsumata*: it is these three that foster, nurture, and stand guard over *washi*. All three are excellent, dependent on your taste and the intended use. Whichever you choose, the result will be a momentous encounter with the beauty of *washi*.

There are two methods of making *washi*:

tame-zuki and *nagashi-zuki*. They originally constituted one method, but over time they split into two. From this we can gain an understanding of the long history of Hosokawa paper and how it combined these two methods. *Tame-zuki* thrives in stasis, *nagashi-zuki* in movement. It is these two methods that bring *washi* into being. *Tame-zuki* lets the fibre settle in the screen as water drips through and the right thickness is reached. The Tori-no-ko paper of Fukui prefecture (formerly Eichizen province) is a famous example of this method.

However, *tame-zuki* is not unknown outside of Japan. What surprises most people about Japanese handmade paper is the *nagashi-zuki* method. This procedure consists of pouring the pulp solution onto a lathed screen and shaking the frame. This causes the fibres to align, intertwine, and grow heavier. When the right thickness is reached, the water is quickly drained, bringing the process to an end. It all depends on manual dexterity. Without deft hands there is no *nagashi-zuki*. The word 'handmade' fits this process to a T. Senka, Shoin, Sekishu, and other types of *washi* are made using this method.

In this process there is one material that performs a miraculous function. This is *tororo aoi*, which is a viscous substance extracted from the root of the hibiscus manihot to make a mucilage. *Tororo aoi* is absolutely indispensable in the making of *washi*. I am not sure who first discovered it, but this transparent, viscous substance plays an important role in making *washi* what it is. It causes the fibres to remain suspended in the water, slows the movement of the pulp solution, and enhances the intertwining of the fibres. After the water has drained off, the waste material is removed and the pulp is taken off the screen, making the resultant layers of paper easy to handle. It is thanks to *tororo aoi*, which facilitates the dexterous movement of the hands, that the beauty and strength of *washi* is produced. One cannot help being amazed at the wonderful workings of nature. It is at this point, with the blessing of nature, that the final product can truly be called *washi*.

It goes without saying that superlative *washi* was made in the past. Even today, however, it is still possible to create and obtain wonderful examples of the art. Although there has been an overall

decline, workshops carrying on the tradition still exist here and there, a phenomenon that must be unique to Japan. Even more wonderful work is possible in the days ahead; there is still unlimited room for development. Our hopes for the future are immensely encouraging. Starting now, we can begin to strengthen our already preeminent position in the world of paper. By adhering to the laws of nature, by giving them life, there is nothing beyond our capabilities. With the will and the resolution, we can achieve a historical transformation. That is what I believe.

Whatever happens, the world of *washi* must not die.

Kogei magazine. Issue no. 28 (special issue on Unshu and Sekishu *washi*).

SEEING AND KNOWING
1940

I

To see and to know are not necessarily the same.
If they happen to be the same, there is nothing
more fortunate, but it often happens that they
have become estranged. Depending on your occu-
pation, this may not present a problem, but for
people who claim to be scholars of aesthetics or
art historians, it can lead to tragedy. While this
situation is not unusual, it is odd that it has never
been much remarked upon. I can cite any number
of instances. If, let us say, someone without any
religious feeling should write a detailed discourse
on religion, there would inevitably be something
missing, and it would lack authority. Or say there
is a moral philosopher of dubious morals. He may
be a brilliant thinker, but can he win people's trust
in the end? Whatever he writes will lack the ring
of truth. Among these various tragicomedies,

what concerns me most are those connected with art. I know any number of art experts who totally lack an eye for beauty. I would not trust their judgment one iota. They are academics specializing in art, but they are not art lovers in the true sense of the word. A teacher of philosophy and a real philosopher are not the same. Neither is a history buff the same as a historian.

II

Conversely, there is the opposite view. Looking at something beautiful, is our experience complete without some knowledge of the object of beauty? Without a modicum of knowledge, can we really say that we are 'seeing' in the fullest sense of the word? Socrates believed that knowing and doing were ultimately one and the same. Similarly, I believe that to see and to know, two facets of one unified whole, is the ideal state. However, in reality, this is not easily accomplished. Human beings tend toward one pole or the other, generally producing an unfortunate split between knowing and seeing. The disastrous consequences of the former approach far outweigh those of the latter.

With respect to beauty, to be lacking in the ability to see is to be lacking in the primary foundation for the appreciation of art. To be highly intelligent does not necessarily mean that one has an eye for beauty. Detailed knowledge does not in itself qualify one to be called a lover of art.

In my view, the relationship between seeing and knowing is similar to the interior and exterior of a building; it cannot be likened to two buildings standing side by side. It is a hierarchical arrangement, not one of two equal entities. In the field of art, intuition is far more important than intellect, far closer to the essence of beauty.

III

Those who first grasp an object intellectually cannot hope to comprehend its beauty. True sight looks within an object, whereas the intellect merely surveys its surroundings. For a true understanding of art, in order to touch its essential nature, instinctive insight must precede cerebral discrimination; intuitive understanding must come before intellectual comprehension. In that sense, the former delves more deeply into

the heart of beauty. Therein lies a profound communication with truth, even if it is difficult to put into words.

Beauty is a kind of mystery, which is why it is difficult to explain intellectually. Ultimately, what can be known with the mind lacks depth. In saying this, I may appear to be negating the study of aesthetics, but in support of this view I would like to quote the words of Thomas Aquinas (1225–74): 'Just as it is said to be impossible to know God, there are no words that reveal a knowledge of God'. Aquinas was the preeminent thinker of medieval Europe, but he knew full well that his knowledge was as nothing when compared to the omniscience of God. Realizing this, he was still the most profound thinker of his day. He is famous as a theologian, but it is as a believer that his true greatness shows. Without faith, he would have been nothing but a commonplace philosopher.

IV

Those who know intellectually without seeing intuitively fail to understand the mystery of art.

Even if they should make the minutest calculations about the nature of beauty, would the result, in fact, lead to true understanding? Beauty that can be neatly cut and spliced is not profound beauty; it is not worthy of serious consideration. Scholars of aesthetics must not build their theories on knowledge alone. They must not deduce seeing from knowing. That would be putting the cart before the horse.

Take a living flower, for example. We can analyse it in terms of petals, stamens, pistils, pollen, and so on, and mount the flower as a specimen. However, once dissected, the pieces cannot be put back together to recreate the living flower. The kinematic can be transformed into the static, but not the reverse. What is dead does not return to life. In much the same way, movement that can be seen can be transformed into movement that can be studied. But seeing cannot be deduced from knowing. The results of intuition can be studied by the intellect, but the intellect cannot give birth to intuition. This is why the fundamental study of beauty should not be built on abstract principles. Scholars of aesthetics who lack the ability to see are ignorant of the fundamental power of art. At

the very least, they cannot speak with authority. Yet there are a surprising number of scholars who are devoid of intuitive insight.

V

Let us take a look at how one of these scholars or critics goes about his work. Let's say he is going to write a commentary on a particular painting. If he is not a man of intuition, certain features will characterize his approach. First he will try to place the painting genealogically, or he will try to define the painting by assigning it to a particular school. He feels uneasy unless he succeeds in doing this. To his mind, a commentary must leave no questions unanswered. It is of vital importance that the painting be properly attributed, dated, and so forth. He feels a deep sense of satisfaction when his commentary has explained everything intellectually. He is mortified when there is an element of mystery left unaccounted for. He is what people call a principled scholar. Yet, in a sense, this is all he is capable of; he can do no more. But is this enough? Is this sufficient to explain what beauty is?

His writing, without fail, is accompanied by certain features. Foremost he employs a plethora of adjectives in his struggle to depict the beauty of the object he is writing about. Sometimes he is bombastic, sometimes strange, sometimes simply odd. But more than anything, he is extremely wordy. He seems incapable of speaking of beauty without innumerable layers of adjectives. This is by far the most outstanding characteristic of this type of writing.

Why should this particular quality always appear? It is the result of an attempt to understand beauty by means of abstract thought. Our writer is attempting to make the transition from knowing to seeing. Since his thinking is based on one rather than the other, he has no choice but to rely on abstractions. The plethora of adjectives is necessitated by this theoretical approach. Since his discourse cannot be based on feeling, it must be based on knowing. His feelings being weak, there is no choice but to simulate them through an accumulation of adjectives. If the heart were full to overflowing, adjectives would be redundant. What is needed are words that go beyond words. Beauty that

can be described in words is not beauty that has been deeply felt.

VI

When knowing is not accompanied by seeing – that is, when the power to see is lacking – art historians, critics, and collectors alike tend to fall into a common error. This error can be described as follows. Even when these individuals rightly praise something as beautiful, unfortunately they then go on to praise what is ugly with the same degree of enthusiasm. This regrettable development should serve as a warning that their praise of the beautiful has not been made for the right reasons. Their discrimination between one and the other is too nebulous and vague. They don't have a firm idea of what constitutes beauty. As a result, they devote themselves to the detailed study of subjects that are of no historical importance. They treat the beautiful and the ugly as if they were of equal value. In a word, they are unable to distinguish between the good and the bad in art. Even when they happen to be right, it is

simply a matter of luck, a fortuitous shot in the dark. Moreover, since the world of beauty is above all a world of value, its very foundation is lost when its standards fall into confusion, when it loses any yardstick of judgment, or when concepts without aesthetic value become the ideal of beauty. Unsurprisingly, any theory of beauty built on such unstable foundations, no matter how cleverly propounded, will necessarily miss its mark.

Art collectors are the most egregious example of this phenomenon. The world seems to be full of art collectors, but rarely is there a collection that has been built on reason and principle. The collectors themselves seem to have no clear standard. Moreover, factors unconnected with proper aesthetic assessment have come to play an inordinate role. For example, there is the strain of thought holding that anything expensive must be artistically valuable, despite the obvious fact that high-priced objects are not always beautiful. This type of thinking is particularly rife among manipulative art dealers. Many reasons can be proposed for considering something valuable: its

rarity, its pristine condition, whether or not it has a seal or signature. However, none of these factors have an inherent connection with beauty.

Attempting to find the essence of beauty in these extraneous factors is a sure sign that the object has not been intuitively seen. When intuition is possessed, these other conditions are largely irrelevant. True beauty remains unaffected regardless of the presence or absence of a signature or seal, regardless of the issue of rarity, regardless of questions concerning immaculate condition. Any assessment of beauty must be centred on beauty itself. Collectors without intuitive insight are unqualified to judge and collect. Sadly, there are innumerable collectors of this sort, accounting for the lack of persuasiveness in their collections. This is an inevitable result of indiscriminately mixing the good with the bad. There is no rhyme or reason to what they collect, no overriding rationale. It is amazing how many collectors collect what they shouldn't; how many don't collect what they should.

For those who rely on the intellect, this is their greatest danger.

VII

The issue of seeing and knowing can be approached in one more way. Seeing is connected with the world of concrete things; knowing with the abstract. Simply put, the one concerns 'things', the other 'circumstances'. For example, let us say we have a painting by Tawaraya Sotatsu (early 17th century) in front of us. The painting itself is a thing, and its beauty is an indivisible part of its being. Seeing its beauty means coming into direct and immediate contact with the thing itself. Circumstances concerning Sotatsu's artistic affiliations, the era in which he was active, the date of the painting's seal, the nature of his painting materials, the sort of life he led – these are not implicit in the painting itself; they are only properties and relations with indirect relevance to the work in question. They merely constitute the circumstances concerning the painting, which, as a field of knowledge, can be studied intellectually. They are merely what surrounds the painting, its properties and relations; the painting is the thing itself. Knowing an object's circumstances in detail can be helpful in coming to a fuller

understanding of its nature, but this alone, without intuitive insight, brings one no closer to grasping the essential nature of beauty. In brief, it is impossible to start with a study of circumstances and arrive at intuitive understanding. One can study an object and note its features, but that only touches the surface. A knowledge of an artwork's properties does not lead to an understanding of its essence. The ideal would be a fusion of the two, knowledge and intuition. Yet in order to grasp the essential nature of an object, what is needed most of all is penetrating insight, that is, intuition. This is why 'seeing' is of paramount importance. Ultimately, the mystery of beauty can only be resolved by proceeding from seeing to learning. The reverse path is not only extraordinarily long but exceedingly convoluted. Individuals who are primarily interested in the 'circumstances' of art are unlikely to ever grasp its essence.

VIII

The ability to see and the ability to know are, in part, innate talents. The former, in particular, is

something one is born with; it cannot be wilfully created. The latter is also, in part, an innate gift, but it can be improved upon through study. By earnest study not a few people have elevated this faculty to a supreme degree. The ability to see, on the other hand, is wholly innate. This is also true of musical talent and the ability to draw, areas in which not everyone is equally endowed.

Put in this way, however, it may seem that I have fallen into fatalism. Is there no way of enhancing the ability to see? Since seeing is ultimately a state of mind, a mental process, there are two or three things I can propose as being relevant. My primary piece of advice is, when first looking at something, do not judge; do not let critical thoughts come to mind. Developing this noncritical attitude is of utmost importance. It means, from the very start, not to make the object a subject of intellectual consideration. Otherwise, you cannot be said to be prepared for the act of seeing. In other words, you should first adopt an accepting attitude. Don't push yourself to the forefront but lend an ear to what the object has to say. This passive

stance is extremely important. It can be likened to a mirror that passively reflects whatever is before it. Just as a polished mirror reflects a clearer image, your mind is best cleared of all extraneous thoughts. This prepares you for the act of passive seeing. To clear one's mind in this way may appear to be a negative act, but in fact it is this negativism that makes possible the positive act of seeing directly into the essence of the object.

Alternatively we can look at this issue in the following way. When the faculty of knowing is employed initially, the faculty of seeing becomes constricted and constrained. We need to free ourselves from these constraints. Without this freedom, we cannot hope to see the essential nature of the object. There is the Zen saying, 'There is not a single disruptive thought', which hints at the activity of seeing without extraneous baggage. Conversely, it means to allow the object to exercise its own innate freedom. Before we begin to express our thoughts, we first have to listen to what the object has to say. In our appreciation and awareness of beauty, we must first of all rein in our tongue. Later, looking

back, we are free to express what we think, but at the beginning we must avoid speaking up before we are spoken to.

Consequently, to improve our way of seeing, we must train ourselves to excise all constraints and constrictions on its proper functioning. This is much like religious training or other types of self-education. Once that is done, beauty will no longer hide behind a veil.

'Know after looking; don't look after knowing'. Heart Gatha, woodblock print by Shiko Munakata.

A LETTER TO MY KOREAN
FRIENDS
1920

In 1910, in response to the Russian Empire's southward expansion policy, Japan annexed Korea with the acquiescence of the United States, Great Britain and other great powers. Within Korea there was resistance to the annexation, and on March 1, 1919, this movement spread throughout the country. The Japanese authorities attempted to suppress it. Learning of the situation, Yanagi wrote this essay in the form of a letter to apologize for Japan's action, to ask for restraint on both sides, and to express his esteem and admiration for Korean art and the Korean people. It was meant to be read by the general public. The essay was published in Japanese in the magazine *Kaizo*, but in heavily censored form. A partial English translation was carried in *The Japan Advertiser*, followed by one in Korea's *Dong-A Ilbo*, but was discontinued after

the April 20th and 21st issues. [The Japan Folk Crafts Museum]

It is with utmost sincerity that I write this letter to my Korean friends, both known and unknown. The kind and sympathetic feelings of the Japanese people for Korea demand that I do so. I would like to speak of things about which it is difficult to remain silent. I fervently hope that this letter will be accepted for what it is. If it should bring the hearts of the two peoples together, I would be elated beyond words. I hope that you will break your sad silence. People want a friend to whom they can speak of things of the heart. In particular, I feel among you a heartfelt desire for human intercourse. So thinking, how could I not take up my pen? When you receive this letter, please do not hesitate to reply. This is my sincere desire.

I

These days my mind is entirely occupied by thoughts of Korea. I cannot fathom why events have turned out as they have. I cannot find the words to explain my feelings. When I imagine the sadness and sorrow you must feel, I find my

eyes welling with tears. I contemplate your fateful destiny. I contemplate the aberrant events of this world. Things that should not take place are, in fact, transpiring before our very eyes. I can find no peace of mind. When my thoughts turn to you, I share your torment and agony. I feel some unknown force calling out to me, a voice that cannot be ignored, a voice that has awakened in me a love for all humankind. This voice draws me strongly towards you. I cannot remain silent. Why am I not allowed to grow closer to you? When affection arises in the blood, heart wishes to speak to heart. If possible, I would like to extend to you a warm hand. In this world of ours, this is only a natural human act, as I believe you will agree.

Human beings have an inborn love of human life; hatred and conflict cannot, I believe, be humankind's innate nature. However, owing to various immoral motives, countries turn against one another; people grow apart. The impetus of evil leads to arrogant hegemony. But this aberrant development goes against nature, and cannot continue forever. Every mind, every heart, yearns for a return to nature and peace. If all returned to

what is natural, all would experience a greater degree of love. Now, however, unnatural forces rend us asunder.

There is the teaching 'Love thy neighbour', but before this adage appeared in the world, there was a natural, innate human feeling of wanting to love. 'Love' is not admirable and profound because it has been propounded by the wise; it is profound because it is based on natural human feeling. If people could only live based on their innate humanity, how much better the world would be! What is most commendable and laudable in this world is not, in my opinion, authority or intelligence, but commonplace human feeling. Now, however, for various reasons, common feeling is being trampled on, and money and military might are considered the pillars of life: to the extent, in fact, that the old adage might be revised to 'Hate thy neighbour'. Countries are constantly preparing for war with one another. How can this inhuman turn of events possibly lead to lasting freedom and happiness? Rather, it simply grows more rampant, dividing one heart unwillingly from another. When I think of the history of Korea, its

successive eras of military oppression and suppression, the crushing of its natural humanity, my eyes fill with tears.

Korea is now in the sad throes of a profound agony. Its flag is not flying proudly; in spring the plum trees refuse to bloom. The unique culture of Korea fades further into the past, disappearing from its place of birth. The vestiges of Korea's unparalleled history will now be chronicled only in books. People pass by in the streets with bowed heads, torment and loathing written on their faces. Even their voices are low and indistinct, and they shun the sunlight, gathering in shadowy places. What force has brought about this change? Seeing the darkness that shrouds you, body and soul, I cannot help being moved; there are times, I am sure, when you shed tears of blood. People can manage to bear up under normal troubles and travails, but life is unsustainable when love and freedom have ceased to exist. Unfortunately, it is not only you who are suffering. Throughout the world countless people are desperately seeking love and freedom, leaving their homelands behind, aimlessly wandering the earth. All people, regardless of who they are,

291

want to breathe the air of freedom. They yearn for the warmth of human kindness. Thinking of this, thinking of such forlorn people, I feel an irrepressible sympathy well up in my heart for you. In the past, has there ever been a country whose politics were based on common humanity? Has there ever been a military conflict that was based on love? Conflict generally lacks morality; it invariably lacks religion. When the people confront this realization, they descend into despair and distress. As for myself, it is my heartfelt hope that Japan be a country that is based on rectitude and humanity. If Japan should become proud of engaging in inhuman deeds, then it must forfeit any claim to religious feeling. Now, unfortunately, the relations between Japan and Korea cannot be said to have a moral basis. Much less can they be said to be based on religious love. In fact, disreputable and heinous acts are often carried out in the name of the nation. Nations do not always abide by the truth; instead, truth is manipulated and distorted. Unnatural forces walk the streets unashamedly in the light of day. But while most people are aware of these crimes being committed in the name of the nation, they

overlook them as being unavoidable incidents in an imperfect world. However, if a whole nation should suffer in consequence, these deeds are shameful for the offending nation and deplorable in the eyes of the world. There is no reason why a righteous Japan should not refrain from such deeds. It is our perennial hope that Japan can be raised up to the level of truth. Even though I have not committed the deed myself, when a case occurs in which Japan does something unjust, I feel the need as a Japanese to offer my apologies. I feel the need to ask God's forgiveness. It is difficult for me to see Japan, a country blessed by the gods, looked upon as morally wicked. For the glory of the country, I would like to see Japan elevated to a higher plane through the power of religion. Even though I might not have witnessed them personally, my heart is rent when I hear of the deplorable deeds carried out among your people. In face of the fact that you are forced to remain silent as you confront this fate, I am at a loss for the words to express my feelings. I can only whisper an appeal for forgiveness: 'If Japan is truly in the wrong, there will surely come a day when individual Japanese will rise up in your

support. The true Japan does not desire cruelty or atrocity. At the very least, it is my fervent hope that the Japan of the future will be a protector and defender of humanity and the humane.' I hope it is not too much to ask that you believe in my sincerity.

Recently, with each passing day, we two peoples grow further apart. It seems strange, indeed, that the desire to come closer together should be transformed into hatred and estrangement. Some profound force must come into being that transforms loathing back into natural love. I am fully aware that Japan as a mighty nation is incapable of achieving such harmony, but Japan as a humane society can, I feel. This cannot be done by force, however. What will bring peace to the world are the tender feelings of the heart. I sincerely believe that you, as warm-hearted human beings, will be able to soften your hearts once again. I have no idea how Japan will attempt to resolve this conflict. And I may be only one individual, but I hope you will accept my love and affection as a living force within your hearts. While it is true that not many Japanese are proclaiming their thoughts, I

know full well that there are many, like myself, who are genuinely concerned. Most of all, I hate to think of Japan as regarding Korea's fate with cold, unfeeling eyes.

How many unjustifiable contradictions there are in this world that remain unresolved! What if – I can't help thinking – Japan were placed in Korea's position? It is likely that Japan, in the name of patriotism and adhering to the call of loyalty to nation, would fly the flag of defiance even higher. We have always held righteous acts in high regard. To now fault your love of country would be an indefensible contradiction. While truth should be universal and unchanging, there are times when the selfsame act is called 'loyalty', other times when it is called 'treason'. How numerous such cases are in this world of ours! How numerous the people who, as a conse-quence, must live in dark shadows! Whenever I think of your situation, when I think of the 'dark forces' that have placed you there, I feel a wound open in my heart. Sometimes this wound is due to the violence of my emotions, sometimes due to deep depression. I know that your hearts must be painfully oppressed. In what, I wonder, do you

seek consolation? What are your thoughts on your present fate? There must be little rest even in your dreams. I pray in my heart of hearts that you will find at least a modicum of peace.

I still retain high hopes for humankind. Someday human beings will come to realize what is right. It is my hope that one day Japan will stand on moral principles. For this should be the ideal embraced by all countries, regardless of time or place. I have no doubt that Japan will one day embrace truth as a pillar of its existence. Young Japanese, I know, are striving toward this goal. Please do not disregard this effort by your fellow beings. It is not wrong, according to my observations, to say that there is hardly a single Japanese who harbours animosity toward Koreans on an individual level. Rather, through the medium of handicrafts, we have always held a high regard for the excellent qualities of the Korean people. Even during the war with Russia, we daily studied and learned much from Russian thought and literature. When two countries part ways, it is not due to individual ill will. We must never forget that our friends in neighbouring countries are also our comrades in

common humanity. The least that can be said is that the young people responsible for building the future of Japan are not unprincipled, cold-hearted individuals.

If Japan should grow arrogant in its military might, there will immediately appear among its citizens those who support your cause. I believe in the basic goodness of humanity. I have faith in the Japanese people as human beings. Human beings do not take pleasure in wrongdoing. They do not turn a cold eye on tragedy and unhappy events. Conflict and oppression are not what they seek. The present world has given rise to perverse movements, causing unintended unhappiness in our daily lives. But what people genuinely want, I believe, is a life that is rich in joy and filled with human warmth. Even if a dark age should come upon us, it cannot change human nature. Natural forces are always there as a firm support, with the power to revitalize and renew. Now, however, country vies against country, people turn against one another. If only people from different countries could be open with one another, what happiness that would bring. Friendship among strangers is especially precious. This is the

happiness that human beings seek. In this regard, I firmly believe that the Korean and Japanese peoples will always be as one.

The Korean people and the Japanese people are like blood brothers, whether in terms of history, geography, race, or language. I don't consider the present situation to be natural or inevitable. I don't believe that the present relationship should continue forever as it is. It is a universal law of nature that the unnatural should be weeded out and die. I sincerely look forward to the day when this unnatural relationship will be corrected. Korea, which is a blood brother, cannot and should not be treated as a virtual slave. This is not because it brings undeserved dishonour to Korea, but because it brings deep disgrace to Japan. I don't believe that Japan will thoughtlessly dismiss this disgrace. Rather, I believe in the future of the country. I believe in Japan's humanity. Young, spirited Japanese feel it their duty to raise Japan to a higher level of truth. I would like you to join me in believing in them. By trusting in the goodness of human nature, together we can renew our hopes for the future.

If a government policy is enacted that contravenes common humanity, that policy cannot expect a long life. No matter how powerful a force might be, it cannot defy the will of God. If it did, its eventual fate would be to collapse from within. Given basic human nature as conferred by God, human beings are called upon to be a benefactor to all living things. All people, all nations, who do not follow this principle will be disgraced and dishonoured in the end. When there is a country that is oppressed unjustly, righteous feelings will eventually arise, and people will stand side by side with the oppressed. This type of heroism, this bravery, born of fundamental human decency, will never die. Those who oppress, rather than those who are oppressed, are closer to eventual extinction. The oppressed will surely win friends and allies, and the oppressors will surely be punished by the laws of nature. Jesus said that those who live by the sword will die by the sword. The rule of evil will not last long in this world.

Here I would like to humbly ask for a moment of reflection. Just as our injuring you in the slightest way with our military sword is a great

evil, I cannot help noting the harm inherent in the path of bloody rebellion. What does it mean to kill, to fight to the death? It clearly means to go against the laws of heaven, to contravene common humanity. It is cruelty incarnate, the most unnatural act imaginable. It can never, ever, be the right path to harmony. How could murder ever lead to harmony? We must always lend an ear to our better nature, which tells us to love one another. Why can we not live naturally in accordance with our finer human inclinations? What does it mean to engage in conflict, to war against one another, even when it goes against our natural human feelings? Even the ancient Chinese philosopher Laozi (6th–5th century BC), who plumbed the depths of nature, spoke out against war in the *Daodejing*.

Here again I would ask you to reflect. If military might and the politics of hatred are degradations of the human spirit, it follows that Korea must not establish itself upon such power and strength. I do not revere military strength or its politics in the least. That is not what brings countries together. That is not what unites individuals. From the ancient past, have there ever

been two countries that have established amicable relations by following this path? Peace based on military force and political machination is nothing but a relationship based on temporal convenience. Or if not that, it is peace brought about by compulsion. I don't want Korea and Japan to descend into this kind of relationship. But you, too, must not trust in the use of force and its politics. No matter what the country, the politics of force does not bring comfort to the human heart. What brings honour and credit to a country is not its politics or military might; rather it is religion, the arts, and philosophy. If there exists a political system that can be truly trusted, it is that propounded by Plato and Confucius. Unfortunately, however, the modern day fears the voices of such wise men. We, however, must believe that the teachings of the ancients were meant to lead us to a greater end. I fervently hope that Korea will establish itself on a spiritual foundation. This represents an ideal for which we Japanese must also strive.

Undoubtedly you have now lost all trust in politicians, but I ask that you not lose trust in all human beings. There are still those who seek

the warmth of true love and genuine peace, reju-
venated by the eternal laws of nature. No matter
how cold the world becomes, nature will con-
tinue to send forth the buds of life. No matter
how hard-pressed Korea is by the forces of the
sword, human beings will, I am convinced,
stand steadfastly by your side. I firmly believe
that one day Korea will be a country warmly
cloaked in human kindness. No matter how
filled with carnage the world becomes, the
warmth of human kindness will never perish.
You may say, given the cruelties of your past his-
tory, that it is impossible for you to place your
trust in anyone. Still, just once more, I would
like you to evoke basic human nature in your
sad, forlorn voices. Ah, how I would like to be a
part of that new age! How I would like to take
your hand in friendship! Yet, as soon as you see
me, will you think, 'Oh, another deceiving Japa-
nese', and reject my advances? Still, I will not
give up until my face shows the sincerity I feel,
until it is clear that I am different from some
other Japanese. I truly believe that you yearn for
genuine human contact. What sincerity I pos-
sess will surely bring us more closely together. If

we should not come closer, that is not due to any fault of yours; it is because my feelings of sincerity are lacking. In that event, I must purify my thoughts and try once again.

Japan does not yet fully possess a human heart. Yet I believe that eventually a young, more spiritual Japan will one day overcome the rule of the sword and brute force. When that day arrives, Japan and Korea will establish relations on the basis of true friendship. Speaking for myself, I intend to work relentlessly towards that joyous day. I can't believe that evil will triumph over good. Rather, I believe in the inner strength of human beings, in the power of truth. I believe that the path of righteousness will emerge triumphant in the end. I am convinced, moreover, that the laws of nature, in all their beauty, will be fulfilled. I am convinced that the power of love far exceeds the power of the sword. I believe that tenderhearted humanity will prove a staunch guardian of peace. Even though corruption may run rampant, I still believe that religion is the force that rules the universe. I further believe that art calms the human spirit and makes the world more beautiful. Conflict cannot be the basis of

life. It is common human feeling in search of love that creates our true abode on this planet. In the inner recesses of the human heart, I believe, there is a deep yearning for human warmth that cannot be obliterated.

Here I will attempt to make my thoughts and feelings a little clearer. First, I entreat you to refrain from judging all human beings solely on the basis of current politics and military oppression. Basic human nature far surpasses these terrible conditions in its profound yearning for true peace and human kindness. Sadly, Japan cannot yet call itself a strong supporter of the true and just. (In fact, how many countries could make such a claim?) Still, you should know that the Japanese are not at heart a people that can look upon tragedy or malevolence with nonchalant unconcern. You should know that the Japanese are a people who devote considerable thought and energy to questions of human relations and the right way to live. Further, you should know that when encountering injustice, they recognize it as injustice and reflect seriously on its causes and effects. Many of us are earnestly attempting to defend and shield what

should be the true destiny of humankind. These protectors and guardians among us are your allies in your time of trouble. I say this not as mere speculation. I am on intimate terms with many people who feel the same.

Last year, when I published the article *Chosen-jin o omou* (Thinking about the Korean People) in the *Yomiuri Shinbun*, I received a great number of letters from Japanese I was previously unacquainted with but who expressed agreement with my views. In the future, when true understanding is established between Korea and Japan, you will come to realize the depth of our affection for Korea. For Japan to love Korea, and for Korea to love Japan, what a natural emotion this is! I am convinced that one day the knowledge that we are truly blood brothers will give rise once again to natural instinctive love. You may doubt this. You may find it difficult to believe. But it remains my fervent hope.

II

I do not possess a detailed knowledge concerning Korea. Neither am I deeply experienced

regarding its current situation. Despite such reservations, however, I am not entirely without qualification to express my views. For some time now I have revered Korean art and have felt toward it a certain kinship. There is no other art that has opened my eyes and heart as that created by your forebears. I know of no other art that is so sensitive to human feeling. Gazing upon this art, I feel as though I am seeing directly into your souls. This is not a matter of historical curiosity but a matter of one heart speaking to another. Therein I can see your perspective on nature and humanity. I can see the purity of your soul, its warmth as well as its sadness and its cry for help. Thinking back, the reason I have such feelings of affection for Korea and the Korean people is due to the impact of its art. Beauty knows no borders. Beauty is where heart and heart meet. It is where human happiness mingles, where you can hear voices speaking in friendly tones. Art connects one heart with another; it is a meeting place of love. Art knows no conflict; it makes us forget our petty selves. It is where we make our home in the heart of others. Beauty is love. The art created by the

Korean people is precisely this art of human feeling, and it is that which moves me. How often I have quietly sat beside it, engaged in endless conversation.

There is no other art that calls for human affection as this does. It is an art that yearns for human kindness, that longs to live in love. It has been permeated by aeons of cruel history, by ages of forlorn sadness. It is the beauty of sorrow, evoking lonely tears. Looking upon it, I feel my breast grow full. No other art is permeated by such pathos. It is a call for human kinship, for human warmth.

What has been your past history, what your philosophy of life? Given your geographical location and neighbouring countries, it must have been difficult to maintain long periods of peace. Carrying in your bodies the quiescent blood of the Orient, nourished by the teachings of Buddhism, you must have viewed any other way of life as an impossible dream. You built the fanes of your heart in quiet woods and isolated mountain villages, perfect places for a cloistered life, loneliness consoling loneliness. You adored the quiet figure of the merciful bodhisattva

Kannon. The ceramics of the Goryeo kingdom (918–1392) proved a means of coming into daily contact with humanity. And this does not apply simply to foregone times. Even during the Joseon kingdom (1392–1897), utilitarian objects retained this comforting quality. Whatever you created or did, whatever could be seen or touched, all had a sense of quiet grief. These sorrowful objects, handled on a daily basis, became your comforting friends; you spent your days consoling and being consoled. They were objects filled with tender feelings. I can now picture them in my mind's eye as if they were actually before me. In the seemingly limitless flow of their lines, they represent a cry from the heart. How much unspeakable bitterness and sorrow, how much unrequited longing, is concealed in the flow of these lines? They are an expression of the fundamental nature of the country and its people. It was not form or colour but line that proved the most suitable means of expressing feeling. Without solving the mystery of line, it is impossible to come to a true understanding of Korean art. It is line that vividly chronicles the pathos of life and the trials and tribulations of history. Its quiet,

covert beauty still conveys to us today the heart-felt beauty of the Korean people. Whenever I gaze at the porcelain sitting on my desk, I feel I can see the tears of its maker shadowed in its quiet glaze.

Now and then these artworks speak to me. 'Life is sad and solemn. Our country has suffered a long, troubled history, but no one recognizes the agony we have been through. There is no friend to whom we can open our hearts. The only thing we can do is to meditate on our troubles and express our feelings in the works we make. It is these works that are our faithful friends. Oh, later generations! Place these objects by your side! In their silence they yearn for human companionship. Handle these objects with affection and warm your hearts. It was for this that they were made.' Ah, when I hear this low, whispery voice emerge from the depths of these objects, how can I not reach out and touch them?

Sometimes a forlorn spectral figure appears before me and says: 'O people of foreign lands! How can you subject us to such horrendous treatment? For you, is our tragic fate a source of

amusement?' Whenever I hear this anguished cry, my heart is rent in two. 'Why, oh, why don't you send us love instead?' asks another spectral figure. 'Why, when we are starving for human affection, why do you refuse to answer with human affection?' I hear another voice say: 'O people of Japan, our brothers in blood! Why do you not send us brotherly love? Were we not born of the same mother, nourished by the same legends – don't we have the same reminiscences of the past? Did we not send Buddhist monks bearing sutras to you, as well as Buddhist statues, and lay the foundation stones for temples in the ancient Japanese capital of Asuka? The culture of the Asuka period (593–710), its religion and its arts, were a gift from us to you, much of which can still be seen today in its original glory. Why can this history not be repeated? Why now do you trample on our cultural relics? Why do you betray our longtime friendship? Who can claim this will bring honour to Japan?' When I am pressed for an answer to these questions, I find myself at a loss for the words to reply.

When I gaze upon these objects, they seem to be bowing in silent prayer. 'O Lord. Allow

our souls to rise to Your place of abode. Comfort us in our troubles. Permit us to be consoled in Your comforting bosom.' Their long, flowing lines seem to be offering up this prayer. Hearing such voices, how could I possibly detach myself from these objects, remove them from my side? Oh, no. Rather, unthinkingly I reach out to them with my hands, to warm them with my touch.

Since coming back from a trip to Korea four years ago, in 1916, not one of these objects has ever left my room. At any moment they seem as if they might want to talk to me. I could not possibly store them away in some cold, dark place. When I place them on my desk, they seem to be pleased. They are always there waiting for me. How could I not reciprocate that feeling? Their beautiful forms draw me to them. When I gaze upon them, when I touch them, I feel a meeting of spirits. They are my good friends, as I am theirs. When they look lonely and sad, I am also lonely and sad. When they seem happy to be at my side, I feel my heart fill with joy. We walk down a path of sadness and happiness together.

These artworks are full of friendly feeling. They yearn for affection, call out to the heart,

pine for the human touch. How could I possibly not respond? I am here, I say, whispering to them in my heart of hearts. To those who crafted these objects I say: 'Rest in peace'. As long as the objects begotten by your hand are in my room, they and I will forever be inseparable. I will never be alone; neither will they. They were made to bring ease to loneliness. I will not leave them in isolation, unbefriended. I know of no other art that is as friendly and approachable. It is a beauty born of human feeling. The word 'intimacy' perfectly expresses its character. Thinking thus, how could I not feel an intimacy with the Korean people today, who share the same blood with these creators of beauty? Somehow, and soon, I must set to rights the present estranged relationship.

However, my appreciation of Korean art does not end with intimacy. I hold its intrinsic beauty in the highest regard. Together with its intimate character, its beauty is an amazing phenomenon. Although Korea has suffered a long, tragic history, in terms of art it ranks as a lord paramount. No person could possibly gainsay that fact. The poets say that art is long, life is short. But the life that appears in Korean art is

eternal and absolute, its beauty deep and fathomless, virtually inexhaustible. Deep down in its innermost being resides a mysterious essence. It is art worthy of display in a sacred temple of worship. While Korea may be outwardly weak, artistically it is strong in its innermost being. It is a majestic, autonomous country, without equal or rival.

Some people say that without the influence of China there could be no Korean art. Or they conclude that without the greatness of China, there would be nothing identifiably Korean. Even qualified specialists occasionally hold this view. But in my opinion this is nothing but a self-deluding dogmatism, an uninformed misconception. Of course, there is no denying Chinese influence, even in the case of Japan. But how is it possible for Chinese feeling to be transcribed as-is into Korean feeling? Given the extraordinariness of Korea's spiritual past and its insight into beauty, how could it merely duplicate Chinese works without change? Even admitting the existence of historical and external influences, there is an undeniable difference in terms of feeling and expression.

The aesthetic sense possessed by the Korean people is unique to that country. Just as its spiritual history is one of a kind, its artistic expression is unrivalled. Some critical historians refer to Korea's historical political policy as a form of subservience to China, but that is not the case when it comes to art. Korean art, in its amazing beauty, possesses a magnificence that is subservient to no other. Take the Pekje-style statues housed in Horyu-ji in Japan. They are in no way inferior to Chinese statuary, and they are not copies or facsimiles. They are called national treasures of Japan, but in fact they should rightly be termed national treasures of Korea. Let us look at the Korean temple Seokbulsa in Gyeongju (8th century). The Buddhist statues there are undoubtedly influenced by the statuary of the Tang dynasty of China, but they are not overt copies or simple emulations. They possess a beauty that is undeniably Korean. I will never forget the day I first visited the grotto of this temple. It was a treasure trove of the depth and mystery intrinsic to Korean art. Some people say that the ceramics of the Goryeo kingdom are nothing but copies of those from the Chinese

kilns of the Song dynasty (960–1279). However, if you tentatively alter the flow of a single line, the beauty of Goryeo is immediately lost. Art is the expression of delicate nuances, unalterable in its essential thusness. The beauty of Goryeo is not the same as the beauty of Song. In the materials used, in the techniques employed, there may be some similarities, but there is an unequivocal difference in the beauty produced. The fine beauty of line seen in Goryeo porcelain cannot be found in the works of the Song kilns. This fine Goryeo line is an integral part of the piece itself, and any alteration, no matter how small, would rob the piece of its true Korean-ness. The same applies to Korea's Joseon kingdom. What is it that sets off Joseon porcelain from that of China's Min kingdom (909–45)? Where lies the beauty of the porcelain of the Joseon kingdom, which was a subservient state to the Min? It lies in its fundamental being, in its vibrant essence. Korean art is incomparable, unique and original; it cannot be violated or defiled. It cannot be unerringly copied or emulated, no matter how skilled the craftsman. It is a beauty made possible only after being filtered through the Korean

heart and soul. For the honour and glory of Korea I want to make this absolutely clear: the magnificence of Korean art is sure proof of the Korean people's amazing insight into the secrets of beauty. And this beauty is not of the roughly made or unsophisticated sort; neither does it consist in some overwhelmingly powerful design. Rather, it is the product of a fine, delicate sensibility. There is not the slightest doubt in my mind concerning the keen aesthetic sensitivity of the Korean people. Through their art I can't help but feel a deep admiration for the people who created it. This admiration is, I am sure, shared by many. This feeling, this admiration and respect, must long continue to be cherished throughout the years to come. As it now happens, however, these artistically gifted people are being compelled by malicious forces to relinquish their unique heritage. I cannot stand quietly by while this deprivation to the world of art is taking place. It is reverence for art that brings countries closer together. It is art that makes the world beautiful. In the distant past it was Korea that first shed the light of civilization on Japan through its religion and art. Today we

should memorialize this fact with a sense of gratitude. It is only right, I think, that Japan should recognize the crucial role that Korea has played in its history. Korea's unique place in the world's art should not be forgotten. As long as the Korean people exist, their art will be repeatedly reborn. To destroy the art of a country, to oppress the creators of that art, is to commit the worst possible of crimes.

A great deal of time has passed since we Japanese first came to admire Korean art, and now its market value has risen remarkably. However, even among the scholars specializing in Korean art there are precious few who have moved from an understanding of the essence of the art to an appreciation of the uniqueness of Korean culture as a whole. Why should the art be lauded but not the people who created it? Although the times have changed, there can be no fundamental change in the people themselves. Even if conditions are different now from what they were in the past, the essential nature of the people is the same. The reason that more recent Korean art has not emerged is simply due to a lack of available time. Here we Japanese must

bear some responsibility. It is my hope that Korea will once again produce beautiful art. My recent acquaintance with two or three artists feeds this hope. If it has been one of the fortunate missions of us Japanese to create museums for ancient Korean works of art, why is it that we have not given proper respect to the artists of the future? To respect and revere the Korea of the past but not to respect the Korea of the future is nothing less than an insult to past Korea. Absolute respect for the past must encompass trust in the future. I feel grateful that the amazing art of the past has taught me to have high hopes for the art of the present. One reason the Japanese administrators of Korea are incapable of understanding the country from the inside is their total lack of education in religion and art. Two countries cannot bond from within by military force and politics alone. What brings genuine peace and understanding to the world is religious belief and living art. This is of paramount importance. Only through these can human beings find their true home. In such a world there is no ill will, no betrayal. If we wish to uproot the sources of conflict and

misfortune from among us, we must establish firm bonds through religion and art. It is this power that will set us on the path to true understanding and loving affection. Although people may say that this is merely an ideal, they should recognize that, in fact, it is the only, the most direct route to amicable relations. Without a moment's hesitation we must do what we can to accomplish this goal.

I do not put much faith in the self-styled 'intimate' experience of Japanese living in Korea. Without entering into the spiritual life of the country, this experience only scrapes the surface; it does not guarantee true understanding. Japanese in Korea possess little religious feeling and are lacking in artistic insight. Most have lost sight of the fact that Koreans are our brothers and sisters; in their pride as conquerors they look down upon you. If they were rich in religious feeling, they would not hesitate to pay you the respect you deserve. If they had an inkling of what generations of Korean people have sought in their art throughout the Joseon dynasty, their attitude would undoubtedly undergo an immediate transformation. We are often visited by

foreign missionaries who come labouring under the delusion that they are members of a superior race, and I can't help but feel that the Japanese are suffering from the same delusion. Yet how can there be friendship where the virtues of respect and humility have been lost? How can there be an exchange of love and affection? The animosity that Koreans hold for Japan is only natural, I think, and Japan must take responsibility for the upheaval it has caused. Japanese administrators in Korea are trying to assimilate Korean culture, but given Japan's own imperfections, what right do they have to do this? Nothing can be stranger or more lacking in persuasiveness. In atonement for its policy of assimilation, Japan has no choice but to accept its result, which is resistance. Just as some people dismissed offhandedly the idea that Japan should be Christianized, you will surely dismiss the idea that Korea should be Japanized. And neither should Korea's beauty and the freedom of its hearts and minds be violated by any external force. No, it is perfectly clear that it is eternally impossible for such violation to take place. True solidarity does not come from assimilation. It

can only come from mutual respect exercised by independent entities.

As a sign of my respect for the Korean people I plan to hold a concert this May in Gyeong-seong, donating the proceeds to the aid and support of Korean culture. I hope you will find it acceptable as a token of my feelings of admiration and affection, as a sign of my belief in the genius of the Korean people. Having often heard of your keen sensitivity in the realm of music, I hope you will find this concert to your liking. Taking advantage of this event, my wife and I are eagerly awaiting the opportunity to meet with you once again. If this should provide the smallest occasion for a meeting of minds, how rewarding that would be! According to one newspaper, the purpose of our trip is to 'educate' the Korean people. This is a complete misunderstanding of our goal, an unbelievably superficial view of our real purpose. In my eyes 'assimilation' and 'education' are stupid, idiotic policies of the worst sort. I would love to delete these words from all Japanese–Korean dictionaries. My dear Korean friends, both those known and unknown, please don't think of me as an exception. Please

believe that I have many principled friends who are sincere in their yearning for righteousness and common human decency. Young Japanese have not forgotten the need to stand guard at the gates of the Kingdom of Truth; they are already your allies. We readily acknowledge you as our close friends. I firmly believe that our bonding is nature's intent. Future civilization will surely owe much to this union of Oriental cultures. In order to present the West with the gift of Oriental truth, in order to eventually forge a union of East and West, the countries of the East must first form closer relationships. Particularly in the case of Korea and Japan, which are connected by blood, there should be a greater sense of affinity and natural affection. Eventually this feeling of friendship must extend to India and China. I hope you will join me in believing that this type of union will be deeply significant for future civilization. This is not just a figment of the imagination. It is, I believe, the voice of nature calling out to us. My thoughts go out to you, far over the sea. I don't doubt that you will recognize the sincerity of these feelings. We Japanese must also answer the voice of nature. We must join

together to live in mutual understanding and common humanity. It is such natural human feelings that bring genuine peace and happiness. It is there that truth will be upheld and beauty come vividly to life.

I think of you, my Korean friends. I think of your fate. I think of your integrity. If, by delivering this letter into your hands, my heart should touch yours, that would be a source of immense happiness. And if you should appreciate my heartfelt feelings, my happiness would be multiplied. In our world today it is such things that bring pure bliss. I believe in my heart that an otherworldly power will bring this about.

With these thoughts in mind, accompanied by my prayers for your happiness, I will now lay my pen aside.

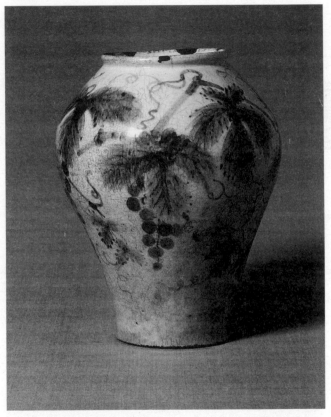

Jar, iron-glazed blue-and-white porcelain, grapes and squirrels motif. Joseon kingdom.

THE JAPAN FOLK CRAFTS
MUSEUM
1947

I. The Genesis

It was January 10, 1926. My colleagues and I had come through Kii (present Wakayama and southern Mie prefectures) and were planning to spend the night at a temple on Mount Koya. It was there that we began discussing the possibility of a folk art museum, talking excitedly late into the night.

It had taken many years for us to reach this juncture. We were all strongly attracted to beauty, and we all shared the same sense of aesthetic appreciation. In retrospect, it is all too clear how different our preferences were from the majority of people. We often found incomparable beauty in myriad things that had previously been ignored. We often found widely acclaimed artwork to be aesthetically wanting. Inexplicably, what we were

strongly drawn to were the utilitarian things that were generally overlooked in the hustle and bustle of daily life. This attraction was not based on some preconceived theory. It was the result of simply looking at things directly, seeing them as they are, an aesthetic stance that was buttressed by the simple process of seeing with one's own eyes before dissecting with the intellect. We would like, we thought, to share the joy this brought us. Through the medium of everyday objects we would like to tell the story of the now forgotten beauty of the past. In this new realm of art we might be able to accomplish something exceptional. Eventually we came to think of this as a duty and obligation. As a result of this feeling, a thought leaped simultaneously into our minds: 'Let's build a museum'.

A similar resolution had led us at an earlier date to build a museum along these lines in Korea. While the Korean venture was on a very small scale, it brought us valuable experience. Feeling inspired, we came to the conclusion that a similar museum should be built in Japan.

As to the museum's collection, it was to focus on one outstanding genre. In order to speak

intelligently of that genre, however, it was necessary to coin a new word. That word was *mingei*, literally crafts of the masses, or folk crafts. This genre consists of utilitarian handicrafts with close ties to the lives of ordinary people. In bringing handicrafts to the fore, we had no intention of claiming that they were the sole source of beauty in Japanese art. We simply wished to establish the fact that, in this largely ignored field, there was artwork of astounding beauty, and that these utilitarian handicrafts formed, as we felt, the mainstream of all craftwork. The museum would be called the Mingeikan, or Japan Folk Crafts Museum, and would come to represent our destined vocation. We felt that if we failed to undertake this mission, there would be no one else who would do so for the foreseeable future. We became convinced that this undertaking would have immeasurable significance not only for the history of craftware and aesthetics, but also for the future of production. Much like a Buddhist monk who resolves to follow the path of religion, we resolved to devote ourselves to the advancement of folk crafts.

How should we go about this project? How

much was it going to cost? How would it be managed? How maintained and sustained? At the time we were too caught up in the project to worry about what lay ahead. While now, in hindsight, it might be said that we started without proper preparation, on the other hand it can be said that what kept us going was our purehearted youthful enthusiasm. Without that, we couldn't have accomplished much at all. Fortunately, our thinking was based on firm principles. We had not the slightest worry about our immediate circumstances. If we ourselves had had the slightest doubt about the future, we would have undoubtedly lost courage.

The work of creating a collection then commenced. As time permitted we spread out over the country in twos and threes, scavenging for suitable objects. This was almost twenty years ago, and so conditions then were very different. Many secondhand shops were unaware of the slang expression *getemono*, which refers to common everyday utensils – much less the newly coined *mingei*. The price of such objects was so low that cost was not a consideration.

Wherever we went was virgin territory. We

were not sure what we would find there, which redoubled the fun of collecting. Most of what we found was at the bottom of dusty piles. As a result, we learned to our joy that we could buy what we wanted at unbelievably low prices.

Gradually the desire to show our collection to the general public gained strength. On June 22, 1927, we held our first folk crafts exhibition on the top floor of the Kyukyo-do speciality store in Ginza.

Through this exhibition we wanted to display what, to our eyes, was authentic craftware. In many ways this exhibition was the first of its kind. None of the objects bore a signature or seal. They were all the creations of anonymous craftspeople, ordinary craftworkers who had created objects of extraordinary beauty. While none of the works had a price of any significance, they possessed a beauty that was worthy of note. By putting them on display it wasn't our intention to shock the world; we merely wanted to share the joy we felt in the presence of their beauty.

Ultimately this exhibition can be seen as an attempt to justify these objects in the eyes of a sceptical world, to develop a new avenue of

aesthetic appreciation. To a large extent it was an attempt to augment and refine the traditional way of seeing things. Hopefully it would propose a new standard of beauty. It was this wholesome beauty, as we saw it, that we wanted to present to the public.

We came to feel that this was work well worth undertaking, especially for the standardless world of crafts, as well as for art in general. Some people viewed the objects we offered as simple grotesquerie, but we saw them as representing the essential nature of art. They were worthy of our guardianship and advocacy.

We were determined to achieve our goal. We harboured not the slightest doubt that such a museum would be highly significant and of inestimable value. However, many of our ideas never reached fruition, and time marched quietly on.

It was about this time that plans were moving forward for the reconstruction of the Tokyo Imperial Household Museum. Nowadays, famous museums around the world have exhibition rooms devoted to local crafts. It stood to reason that the same should be done in Japan. This was

particularly true since Japan was so rich in handicrafts. Surely, sooner or later, the need to exhibit these folk crafts in a museum would come to be felt. This gave rise to one idea in everyone's mind: why not donate our entire collection to the new museum and have it displayed in two or three rooms? We asked for an interview with the museum's director to discuss the matter. Whether it was due to the fact that we had not made our plans perfectly clear, whether the museum was already cramped for space, whether the needed funds were unavailable, or whether our collection was thought wanting – in any case, our proposal was not accepted and gradually forgotten. This breakdown in the negotiations, however, had the ironic result of firing us with even greater enthusiasm. With our own hands we would do something of lasting value; we would keep moving tirelessly forward, waiting for the day when our labour would bear fruit. From our meagre funds we kept adding to our collection, a bit at a time.

In the summer of 1929 my friends and I were sitting on Skansen Hill in Sweden, engaged in lively conversation. The Nordic Museum in Stockholm is far and away the world's most

superlative museum devoted to agricultural life. Its numerous structures are overflowing with tens of thousands of collected items. From wood to metal, textiles, and ceramics, the collection is a consummate representation of the beautiful, sensuous objects of the Nordic peoples. The individual rooms are maintained as they originally were, as though they were still being lived in. This institution was first established by the pioneer Artur Hazelius (1833–1901), who devoted his life to realizing the project. He possessed a passionate love for products made by the people's hands and was determined to preserve and protect them. There were many obstacles to overcome, but in the end his efforts were rewarded. Now his accomplishment comes under the protection of the Swedish government and is much revered. Located in one corner of a small snowbound country, it is an amazing collection, a proud achievement in the eyes of all who see it. Through this collection Sweden has achieved global renown. One of the reasons for our visiting Europe was to call upon this museum.

Should we take this museum as our model? No, definitely not. We had our own path to follow.

Still, one result of visiting this astonishing museum was that we experienced a rekindling of passion for our own museum.

Instead of aiming at comprehensiveness, we decided to aim at quality. We decided to strictly select only what was aesthetically the best. This was our mission as Japanese. We should carry out our choice of objects so that nothing could surpass what we had selected, no matter where the collecting was done or by whom. We would openly discuss our standard of judgment. Without a standard, without self-awareness, this work could not be done. We burned with hope and expectation. We would build a folk crafts museum in Japan.

Interest was sparked in society at large by our second exhibition and the coverage of folk craft publications. Here and there people began to pay more attention to what we were collecting. Some laughed and said we were only interested in what was cheap; others said since we were poor in the pocket, we were claiming that the essentially trivial was, in fact, beautiful. Shrewd secondhand shops suddenly saw a future in cheap things and acted accordingly. In particular, the

folk art exhibitions sponsored by Yamanaka & Company in Tokyo and Osaka in 1930 fanned the flames. Thereafter department stores joined in with their own exhibits, and soon the word *mingei* came to be heard on everyone's lips, even appearing in dictionaries. Opportunity was knocking at our door.

Since resolving to build a folk crafts museum, ten years had flowed by. Looking back, there were a number of miscalculations on our part, but fortunately we were able to retain our faith in the project. Eventually other people also came to see the need for a museum, and our sense of responsibility grew even heavier.

It was then that the most fortunate thing happened. On May 12, 1935, we were visited by the distinguished businessman Magosaburo Ohara (1880–1943), who offered to pay the costs of constructing the museum. It was impossible to find the right words to express our gratitude for his kind generosity. We would now be able to realize our long-held dream. Mr Ohara was widely known for his philanthropic activities. He believed in the work we were doing and even proposed a number of useful suggestions.

Thereafter our little group of believers frequently met to discuss future policy.

First we decided on the site. We contracted for a lot at 861-banchi, Komaba-cho, Meguro-ku, Tokyo, which covered some 1,818 square metres. Next we decided the architectural style, which would be traditional Japanese and make generous use of *oya-ishi* tuff stone. Construction got under way, and the foundation stone was laid in October 1935. The first stage of construction consisted of erecting the main building with a total floor space of 661.2 square metres. Facing the main building was a 'long' stone-roofed gate-cum-residence (*nagaya-mon*) that had been brought from Tochigi prefecture and reconstructed. Later this became known as the west wing. Still later, plans were drawn up for increasing the number of exhibit rooms as well as for the construction of a library, administration office, lecture hall, workshop, and other facilities. While construction was proceeding, we concentrated on collecting more handicrafts and books in various fields, and were fortunate enough to come by some truly excellent pieces.

On October 13, 1936, the construction work

was completed, the collection put in order, the pieces set out for display, and the museum opened to the public. There were six rooms on the first floor of the main building and five on the second floor, as well as three rooms in the west wing, making fourteen in all. The buildings were done in the Japanese style, with lighting provided through papered sliding screens. There were eight alcoves. Given the nature of the museum, the choice of Japanese style over Western seemed the right one.

Almost without us realizing it, ten years passed quickly by, during which time we put up new objects for exhibit four or five times a year and held a number of special exhibitions. Some of the special exhibitions were on such a large scale it would be difficult to re-enact them today, such as the nationwide Japanese folk crafts exhibition, the Korean handicrafts exhibition, the Okinawan handicrafts exhibition, the exhibition of the boldly designed type of Chinese porcelain called *akae*, and the Ainu handicrafts exhibition. All of these attracted a good deal of positive attention. One more outstanding feature of the

museum is the exhibition of newly created works held every spring.

During this time we continued our work in surveying and researching handicrafts throughout the country, finally bringing to an end our far-reaching peregrinations. The general disposition of Japanese handicrafts became clear enough to record on a map. It also became clear through our repeated visits to Okinawa how important this island was to Japanese culture. The items collected there are still an invaluable part of the museum's collection today.

While the Japan Folk Crafts Museum is a typical small-scale museum, no one can fail to appreciate its outstanding features: the size and richness of its collection, the fact that most of its pieces have never been displayed at any other museum, and the care with which the items for display were chosen.

II. The Work

What, then, were we hoping to achieve by founding this museum? What features would set it off

from other museums? What were our ideas, our principles, in undertaking this work? There are many things I would like to say in this regard, but I will pick up only a few.

Over many a year we had searched for a museum that was based on a single aesthetic principle. The closest to this ideal were private museums, among which a number of instances could be cited. With large museums, however, this type of aesthetic consistency is practically infeasible. The reason is that their variegated collections have been built up over the years by a number of different people. Some pieces have been selected because of their beauty, some because they are rare, others because they are famous, still others because of their seal or signature; and finally there are those selected from a historical or archaeological perspective. Since they are chosen for a variety of reasons, it is hard to achieve an organic consistency. Still, such museums serve a purpose if their collections are large enough. The danger is that if there is no recognized standard of beauty, their collected works will become a mishmash of the good and the bad. The museum becomes nothing but a

place for display, losing any educational value. Should there perchance exist a museum that has deep insight and a high aesthetic standard, whose collection is properly organized and consistent, that museum would be an artwork in its own right. In that case, its displays would achieve real authority. Through viewing the arrayed works, viewers could gain an insight into the nature of beauty. Unfortunately, this type of museum is extremely rare, and truly excellent pieces are almost never seen. While our museum may be small in scale, it is trying its best to fulfil this need for consistency.

To achieve this goal, the collection and display of older folk craft objects naturally took on great significance. It wasn't a matter of the old always necessarily being good; it was simply that older pieces represented a greater proportion of well-made objects. Even now there is an extraordinarily large number of old objects that could serve as models of craftsmanship. However, it was never our intention to consider our work over and done with the display of these older works. Rather, that was considered of secondary importance. By telling the story of older works,

we could discover the laws of their creation, and this could serve as a basis for newer work. If one were to confine the appreciation of beauty to the past, it would merely be a frivolous diversion. What concerned us most was laying the groundwork for the creation of new handicrafts, including their manufacture and development. Thus we devoted considerable energy to the display of new work that would form the future. The links to the future were more important than the links to the past. The museum must develop strong ties between today and tomorrow. We felt it our mission to introduce to the public both reliable individual artists and the work still being produced in the provinces.

The museum's principal displays consist of handcrafted objects. When one of the so-called fine arts is chosen for inclusion, emphasis is placed on its handicraft-like beauty. Handicrafts are intimately tied to everyday life. To our way of thinking, beauty has close ties with an object's inherent beauty as a handicraft. Until now, overriding importance has been given to the fine arts, and the world of handicrafts has been neglected. We strongly believe, however, that

handicrafts have enormous significance, both aesthetically and socially. Thus it happens that the museum should make it its main job to collect objects that are aesthetically pleasing as handicrafts. No other museum of this kind exists in Japan.

While there are various types of craftware, we chose to place emphasis on the folk crafts. As I said earlier, folk crafts are handicrafts that are made by anonymous craftspeople and have especially close ties to the everyday life of ordinary people. It is these utilitarian objects that show the highest degree of development as craftware. Among the various types of beauty, we chose to emphasize wholesome, ordinary beauty, and this type of beauty is most often found, we felt, in the folk crafts. While there has always been a tight bond between beauty and everyday life, between beauty and the common people, it has not been fully recognized until now. This is precisely why the fact that our museum is a folk crafts museum is so significant.

It is only natural that a museum should place ultimate value on the beauty of the objects in its collection. The value of an object lies in its

beauty; everything else is secondary. It is very much like the value of human life being characterized as being basically good or sacrosanct. In contrast, qualities represented by riches and power are of minor importance. As a result, our exhibitions display only the beautiful, the result of a very strict process of selection. This process is, in fact, one of the museum's most outstanding features. Strangely enough, no other museum has attempted anything similar.

The museum's mission is the presentation of a standard of beauty. As mentioned earlier, this standard consists of wholesome, normal beauty. As an ideal of beauty, it is unsurpassable. Thus the job of consistently arranging and organizing the individual pieces in accordance with this standard, as well as the collection as a whole, is of vital importance. It hardly need be said that this standard should not be the result of theoretical cogitation; rather, it should be the outcome of keen intuitive insight. This is what separates folk craft museums from ethnographic museums, since the latter are not based on intuitively perceived beauty. Our museum is not simply a place for putting objects on display.

It follows, then, that the greatest possible care should be taken to arrange objects so as to bring out their inherent beauty. How objects are placed, the shelves on which they rest, background colours, and the introduction of light – all of this has a not inconsiderable impact on how the objects are perceived. The way objects are arrayed is an art in its own right, and I would like to see our museum come to be viewed as a work of art. Ordinary museums can easily become cold, static places where objects are set out to be looked at, which is why I am constantly thinking of how our museum can be made into something that is warm and friendly.

While the Japanese government now and then honours certain extraordinary individuals for their contributions to the nation, the litmus test of a country's cultural level should be the lives led by ordinary people. This level is most apparent in the utilitarian objects used on a daily basis. It is through such objects that the Japan Folk Crafts Museum seeks to honour the nation's common citizenry. Here in this museum, more than in any other, the life of ordinary Japanese can be truly seen.

The Japan Folk Crafts Museum (main building, 1937; interior, 1942).